ZHENG CHONGBIN

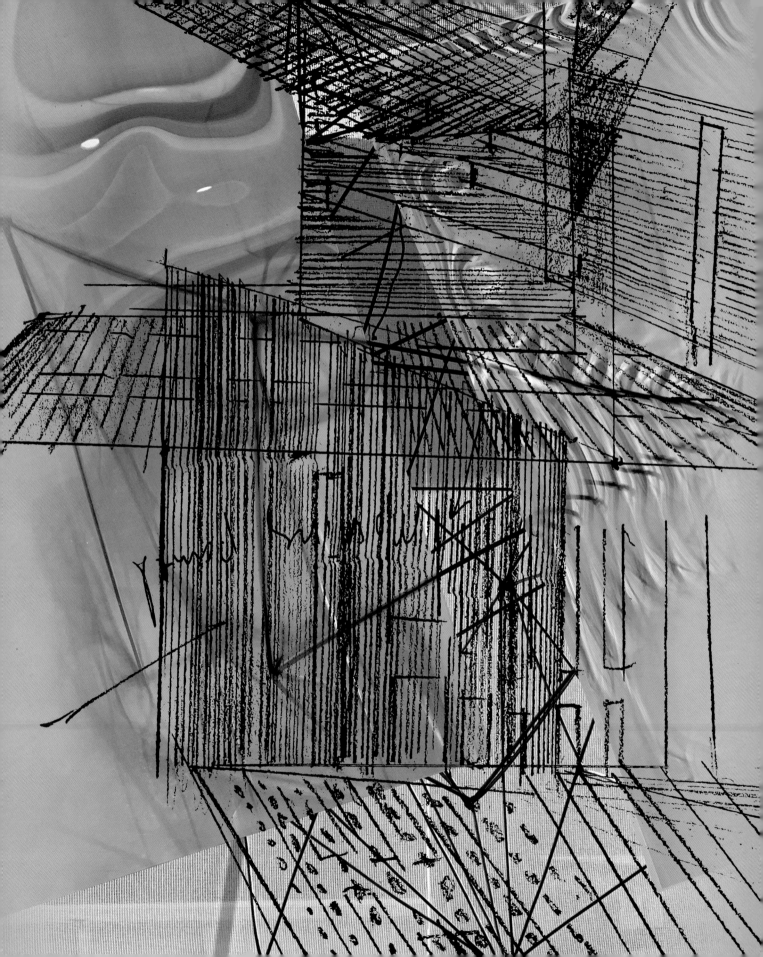

ZHENG CHONGBIN

I LOOK FOR THE SKY

EDITED BY ABBY CHEN

ASIAN ART MUSEUM
SAN FRANCISCO

Asian
Art
Museum

Published by
Asian Art Museum
Chong-Moon Lee Center for Asian Art and Culture
200 Larkin Street
San Francisco, CA 94102
www.asianart.org

Published on the occasion of the exhibition *I Look for the Sky* presented at the Asian Art Museum—Chong-Moon Lee Center for Asian Art and Culture, 2021.

Zheng Chongbin: I Look for the Sky is organized by the Asian Art Museum of San Francisco. Presentation is made possible with the generous support of East West Bank, Lucy Sun and Warren Felson, and an anonymous donor. This exhibition is a part of the *Asian American Experience*, which is made possible with the generous support of Glen S. and Sakie T. Fukushima, an anonymous donor in memory of Ambassador and Mrs. Sampson Shen, and Claudine Cheng.

Sustained support generously provided by the following endowed funds:
Akiko Yamazaki and Jerry Yang Endowment Fund for Exhibitions
John S. and Sherry H. Chen Endowed Fund for Chinese Art and Programming
Arlene Schnitzer Endowed Fund for Chinese Art
Kao/Williams Contemporary Art Exhibitions Fund

EAST WEST BANK

The Asian Art Museum—Chong-Moon Lee Center for Asian Art and Culture is a public institution whose mission is to lead a diverse global audience in discovering the unique material, aesthetic, and intellectual achievements of Asian art and culture.

Library of Congress Cataloging-in-Publication Data

Names: Chen, Abby, 1972- editor. | Kóvskaya, Maya. | Asian Art Museum of San Francisco, organizer, host institution.
Title: Zheng Chongbin : I look for the sky / edited by Abby Chen.
Other titles: Zheng Chongbin (Asian Art Museum of San Francisco)
Description: First edition. | San Francisco : Asian Art Museum, [2020] | Includes bibliographical references. | Summary: "The publication documents a solo exhibition of new works by the Bay Area-based, Chinese contemporary ink artist Zheng Chongbin at the Asian Art Museum of San Francisco. The exhibition consists of two newly-commissioned installations, a large-scale ceiling installation in Bogart Court entitled I Look for the Sky and a second large installation in Osher Gallery consisting of a light tunnel/environment surrounded by an installation of paintings. The scholarly essays by exhibition curator, Abby Chen, and independent scholar Maya Kóvskaya historicize this prominent, mid-career artist and speak to the current trajectory of Zheng's artistic practice"— Provided by publisher.
Identifiers: LCCN 2020024577 | ISBN 9780939117901 (paperback)
Subjects: LCSH: Zheng, Chongbin, 1961—Exhibitions. | Site-specific installations (Art)—California—San Francisco—Exhibitions.
Classification: LCC N7349.Z479 A4 2020 | DDC 709.05/014—dc23
LC record available at https://lccn.loc.gov/2020024577

Produced by the Publications Department, Asian Art Museum
Nadine Little, Head of Publications
Copy edited by Clare Jacobson
Proofread by Ruth Keffer
Designed by Bob Aufuldish, Aufuldish & Warinner
Unless otherwise noted, all images are © Asian Art Museum of San Francisco / Photograph by Kevin Candland.

Back cover and back flap: © Zheng Chongbin
Front flap: © Asian Art Museum of San Francisco/Photograph by Kevin Candland
Inside flaps: © Asian Art Museum of San Francisco/Photograph by Resolution Workshop

10; 18; 32-34; 50 © Zheng Chongbin
46–47 © Asian Art Museum of San Francisco/Photograph by Mira Nguyen
48–49; 53 (bottom-right) © Asian Art Museum of San Francisco/ Photograph by Resolution Workshop

CONTENTS

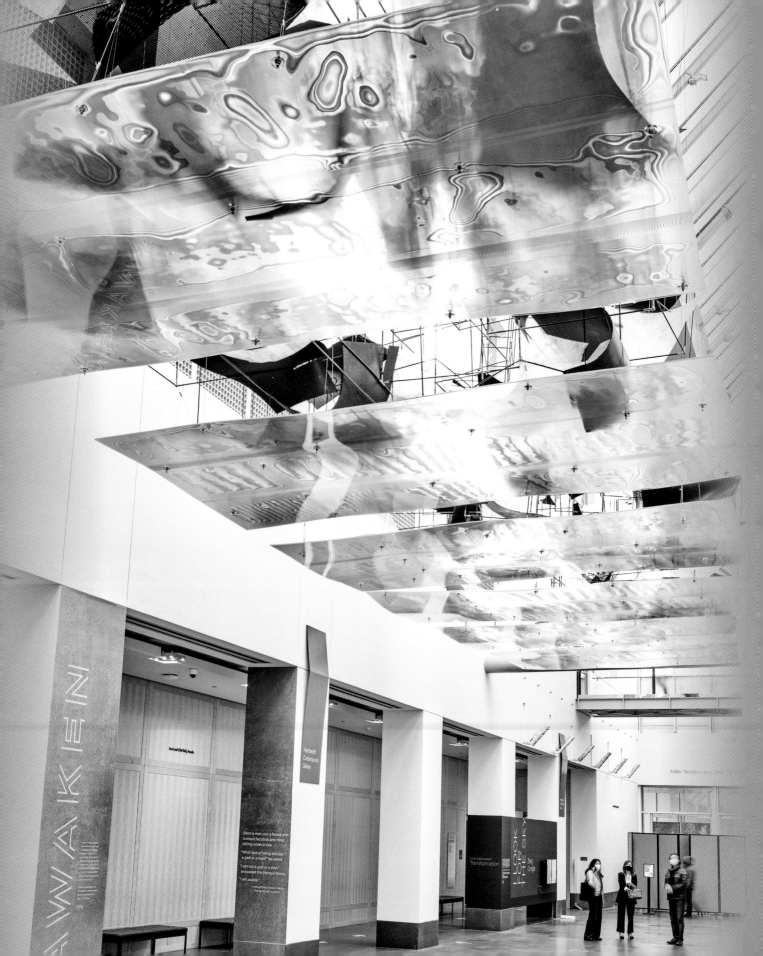

FOREWORD

JAY XU, BARBARA BASS BAKAR DIRECTOR

Zheng Chongbin: I Look for the Sky opens as the museum celebrates a major transformation of our space and at a moment of significant commitment to contemporary art. The installation of this large-scale commissioned artwork in Johnson S. Bogart Court together with Zheng's new work, *State of Oscillation*, in the Bernard Osher Foundation Gallery demonstrates the Asian Art Museum's commitment to contemporary engagement in all of our public spaces. This was launched under the leadership of our recently appointed head of contemporary art, Abby Chen. In her previous post at the Chinese Culture Center of San Francisco, Chen invited Zheng in 2011 for his groundbreaking solo exhibition, *White Ink*, which marked a key shift in his artistic practice. Today's solo exhibition at the Asian Art Museum is an important milestone in the artist's career while his direct artistic intervention in the existing space of the museum represents a significant milestone for the museum as well.

I first became acquainted with Zheng Chongbin shortly after I arrived at the Asian Art Museum in 2008 and have followed his career for more than ten years. Over the last decade I have witnessed a transcendental transformation of the artist and his work. Classically trained in ink painting in China, Zheng's ideas have driven him to tap into all sorts of media—the traditional media of ink painting, the manipulation of space as part of installation work, and the use of new media to manipulate light or create video. In this exhibition he has combined these media and technologies to create a one-of-a-kind experience. The Asian Art Museum is proud to support Zheng's innovative work during this transformational period. The Asian Art Museum has been a platform for many Asian American artists, and Zheng's work illustrates how this continues to be a major focus of our efforts with new art. Asian American artists, including those from our own Bay Area, and contemporary art are now featured throughout the museum galleries.

In this moment of transformation, I am truly delighted and inspired to see the partnership between Zheng Chongbin and our curator Abby Chen. I think the community will be very pleased to see the results. Thanks to all who made *Zheng Chongbin: I Look for the Sky* possible. I am enormously thankful for the sustained support of the Akiko Yamazaki and Jerry Yang Endowment Fund for Exhibitions. I am grateful for support provided by East West Bank, Lucy Sun and Warren Felson, and an anonymous donor.

SEEING THE IMMEASURABLE:
A MEDITATION FROM ZHENG CHONGBIN

ZHENG CHONGBIN

The title *I Look for the Sky* suggests that the works in this exhibition contain no definite form. When I look up at the sky, at the vast universe, the world beyond us seems disrupted. On the one hand, the sky is the realm of abstract physical and biological properties, with phenomena including light, shadows, airborne dust, and other particles. On the other hand, it is connected to us in many concrete ways: we look at it, we breathe air in and out, and we are enveloped in light.

We strive to know what a thing is and how it appears. We attempt to narrow the separation between our perceptions and what the inside of things tell us. The discoveries of modern science constantly change the way we think about things and their ontologies. The sometimes illusory appearance of a thing does not mean it does not exist. Like the light in these installations, existence is not a matter of black and white. Rather, many spectra of existence happen simultaneously. Just as light travels, these installations cannot be viewed in a solid, permanent state. Their multiplicities, their changes, their correlations between visible and invisible temporality, and their radical ambiguity evoke a different reality. In the process of making these works, I hoped that they would show a coming together of the measurable and the immeasurable—a passage in both directions.

This exhibition is site generated. In any given space, there is always a play of light and shadow that surrounds us. Light and shadow interplay in every aspect of our culture, past and present. Light triggers our perception and puts us in touch with what is real. Light thrives in our complex ecological network and alters the environment. Light prompts darkness. Darkness summons light. Light throws a bridge from the known to the unknown universe.

We can always see what is visible, but we know there is a vital hiddenness in the world. We know about microscopic phenomena and the unexpected, underlying nature of physical reality revealed by quantum physics. Between darkness and light, things emerge and clash throughout geologic time. There is a connection—a deep entanglement—between the human and nonhuman worlds, with their constant flux of data.

Art has always been a pathway to this emergent world. It is full of probabilities and chance—and so it was, working on this exhibition. The assembled, fragmented pieces in *I Look for the Sky* were never about a fixed object, but rather about the shifting relationship among the fragments—a resonance, a natural chemistry, a hybridity. Culture and nature need to share the same space; society, all living beings, this physical planet, this Earth are interconnected. This is the conundrum, the challenge we face: to create patterns that are cognizant of what we affect and are affected by.

We have seen a shift from what we thought we knew to the revelations of an unknown reality. Our space is like an invisible, intertwined mesh—and this intertwining comes with complex interactions among multiple entities. As writer Timothy Morton (b. 1968) said, "I can't see it. But I know it exists, and I know I'm part of it. I should care about it."[1]

1 Timothy Morton, "Introducing the idea of 'hyperobjects': A new way of understanding climate change and other phenomena," *High Country News*, January 15, 2015, https://www.hcn.org/issues/47.1/introducing-the-idea-of-hyperobjects (accessed March 24, 2020).

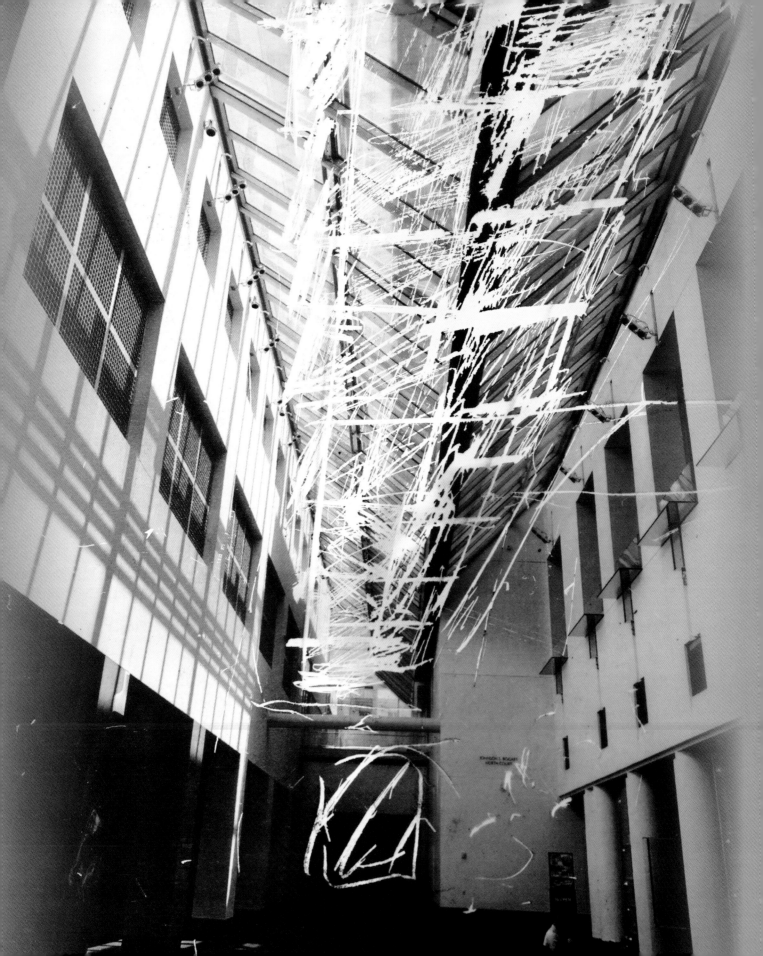

IN THE STATE OF MOVEMENT

ABBY CHEN

Contemporary Art in a Changing Museum

The Asian Art Museum of San Francisco's embrace of contemporary art into its core initiatives is not only a critical addition to predominant museum models of conservation and presentation. It is also a statement that the Bay Area art scene is engaging culturally and politically with the rest of the world. This momentous direction is significant in an era that is extremely complex and turbulent. The increasingly polarized global climate presents urgent challenges for all museums. To stay relevant by leading and responding to the present discourse, museums must set in place a different logic and modality of contemporary art practices that generate new knowledge, as well as a willingness to experiment, even if this could result in unfamiliar conflicts and contradictions.

This is a transformative time for the Asian Art Museum. Building on its long history of expertise in research, publications, and exhibitions of Asian art, the museum opens the Akiko Yamazaki and Jerry Yang Pavilion (Y2 Pavilion, fig. 1) and launches a new era that demonstrates its renewed commitment and promise to amplify the voices of artists of our time. As the museum expands architecturally—with the hope of also expanding demographically—it must welcome and affirm new curatorial strategies that reconcile museum with neighborhood, creativity with pedagogy, local with international, and artistic with social.

These strategies are exemplified by three public commissions visible in both daylight and at night on the Hyde Street facade of the Y2 Pavilion. These artworks—*I was, I am, I will be* by Chanel Miller (b. 1992), *Don't Mess With Me* by

Jas Charanjiva (b. 1972), and *Pattern Recognition* by Jenifer K Wofford (active 1999–present)—address intersectional feminism as well as historically under-recognized Bay Area Asian American art. Together, they stand as landmarks of change, driven by the Contemporary Art department at the Asian Art Museum. They hint at the developing changes within the museum, including the exhibition that is the focus of this publication. By investigating its connection to the history and transformation of the museum and its place in the artist's evolving practice, I hope to suggest the course of contemporary exhibitions to come.

Interventions in Museum Space

When visitors go inside the transformed building, one of the first things they notice is an installation work, suspended from the ceiling, by Bay Area–based artist Zheng Chongbin (b. 1961). This large-scale piece, *I Look for the Sky*, is one of two works in his debut solo exhibition at the Asian Art Museum, *Zheng Chongbin: I Look for the Sky*. These installations were created specifically for the Bernard Osher Foundation Gallery and Johnson S. Bogart Court, the latter being a historically underused area for displaying work that, with this installation, is refreshed with a new mode of existence.

Osher Gallery and Bogart Court were built in 2003, when the Asian Art Museum moved from Golden Gate Park to a building that was originally San Francisco's Main Public Library. For this renovation, the renowned Italian architect Gae Aulenti (1927–2012) was chosen by the museum to "represent the finest international experience in both the design of exhibition facilities and the rehabilitation of historical structures."[1] In an interview with Aulenti in 2001, the architect articulated her vision for the museum "to be a place full of light and air and be 'transparent' to help orient the visitors."[2] She explained that her first step in redesigning the building was to extend the two courts along the north and south sides of the building (Bogart Court and William K. Bowes, Jr. Foundation Court) to bring in a lot of natural light. This effort not only helped brighten the "very closed and gloomy" old building, but also responded to the museum's request to create an "open public space."[3]

Two of the many unique and beautiful characteristics of Aulenti's design for the 2003 renovation are indeed these open public spaces: Bogart Court and Bowes Court. Both courts are spacious halls with high ceilings made of clear glass, connecting the spaces to the sunlight above. Aulenti's concept of "radically changing the attitude of the users of the place" is a source of reference and inspiration for Zheng Chongbin in developing *I Look for the Sky*.[4] Through this work, the artist hopes to create the sense of navigating a new physical and emotional experience, both within the specific context of the Asian Art Museum's overall transformation in conjunction with the new Y2 Pavilion and within the museum's broader contemporary art initiative.

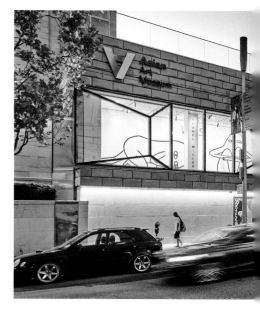

FIG 1: Exterior of the Akiko Yamazaki and Jerry Yang Pavilion. Photograph © Asian Art Museum. Photograph by Kevin Candland

FIG 2: *Wall of Skies*, 2015, by Zheng Chongbin (American, b. China, 1961). Site-specific installation. *Collection of the artist.* © Zheng Chongbin. Photograph © Ink Studio.

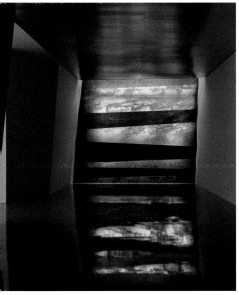

In addition to *I Look for the Sky*, the exhibition features the video and painting installation *State of Oscillation* in Osher Gallery, a space that resides between Bogart Court and Bowes Court. While Zheng Chongbin employs natural light coming through glass to bathe *I Look for the Sky*, he applies the artificial light of projections to illuminate *State of Oscillation*. He uses the experience of entering the enclosed space of Osher Gallery from the adjoined common area of Bogart Court as a metaphor for the intimacy of the interior: the magnified cognition of looking inward. This physical shift that the visitor experiences enables an acute awareness of the changes within the human body, as well as of the perception of the body in relation to its environment. Rays from four projectors, facing two by two, travel into a chamber made of scrim. The beams meet—bouncing and intertwining—to form clouds of illuminated motion. On the perimeter of the room, Zheng Chongbin installs large-scale abstract ink paintings that reflect the light and make the work resemble a sculpture. This is reminiscent of Zheng Chongbin's painting installation *Wall of Skies* (2015, fig. 2), presented at the 11th Shanghai Biennale. At first encounter, *Wall of Skies* might be taken as a folded structural sculpture covered with ink brushstrokes, but in reality the artist created an entire environment by modifying the floor and incorporating light sources in order to subvert our initial perceptions. *State of Oscillation* broadens this concept using more complex juxtapositions of variable elements including painting, video, and light installations as one integrated piece.

Building upon a similar approach to *Wall of Skies*, *Zheng Chongbin: I Look for the Sky* endeavors to reimagine an object-based museum in spatial and conceptual terms—negotiating control with openness, stillness with movement, light with darkness, and the old with the new. The architecture of the Asian Art Museum is also a part of its permanent collection, in addition to the more than 18,000 objects that it holds. Engaging Zheng to make this site-specific installation in Bogart Court generates new meanings not only from this underutilized public space, but also from the museum's historical collection. Contemporary art is, in addition to an art form, a working methodology. Without a holistic institutional shift from its habitual approach of "museumification," a museum will treat an artist as an art object—with fixed terms and conditions. As an effect of the Asian Art Museum's transformed ideology, Zheng Chongbin's site-specific installations invite the audience to activate familiar spaces and infuse them with refreshing energy.

An Evolving Practice and an Evolving Museum

This familiarity is effected in part by the museum's support of Zheng Chongbin in an earlier stage of his career. In 2011, the museum became the first institution in North America to commission an artwork by him: the ink and acrylic painting *Ended Season* (2011, fig. 3). My discussion with the artist to plan for *Zheng Chongbin: I Look for the Sky* actually started with *Ended Season*. The painting was

commissioned by the museum following Zheng Chongbin's solo show, *White Ink*, at the Chinese Culture Center of San Francisco (2011, fig. 4).[5] *White Ink* opened at a critical juncture in his work, when the artist, who had started his career in figurative painting, had matured into abstraction after three decades of living in the Bay Area. The following excerpt from the curatorial statement for the exhibition provides context on the artist's evolution:

> As geographer and philosopher Yi-Fu Tuan [b. 1930] stated in his "Geography, Phenomenology, and the Study of Human Nature," "Home has no meaning apart from the journey which takes one outside of home." To say traditional ink painting is Zheng's home of craft and artistry is no exaggeration. The dislocation from China to the US was a catalyst of his transformation, and the choice he made to go into different genres was an intentional and a conscious one. The willingness and the ability to disengage from the familiarity, and to reconnect back to the root culture after the odyssey, have positioned Zheng as an instrument of cultural translation, which in itself has taken both cultures further to a new present.[6]

Born in 1961 in Shanghai, Zheng Chongbin graduated from Zhejiang Academy of Fine Arts—the premier art school in China, now known as China Academy of Art—in 1984. Trained as a figurative painter, he was among the first generation of artists from China who were allowed the freedom to learn from and experiment with modernist approaches after the Cultural Revolution (1966–1976), which violently suppressed traditional intellectual activities. Zheng Chongbin demonstrated stylistic innovation by assuming a masculine, forceful gesture resulting in biomorphic, abstract forms (fig. 5). He came to study at the San Francisco Art Institute in 1988 as the recipient of its first international artist fellowship. After coming to the United States, he continued to explore expressive forms of performance and sculpture before developing a relaxed yet controlled style of abstraction around 2010.

The abstract ink painting that Zheng Chongbin pioneered through more than thirty years of experimentation is a direct result of how he observed and responded to his different environments. These years happened to witness a significant reshuffling of human experience worldwide. China's booming economy, advances in personal mobility, technological innovations, ecological destruction, and surging interest in contemporary art contributed to an increasingly complicated and rapidly changing environment for people. In a recent conversation, Zheng Chongbin identified 2011 as a turning point of his creative output. He noted that this was when he started to evolve toward what he describes as "material agencies" by creating environments integrated with painting rather than mere spaces for displaying paintings:

> Being away from the self-contained places in which I usually worked opened doors for me. Before 2011, I was working on abstractions, working on forms,

FIG 3: *Ended Season*, 2011, by Zheng Chongbin (American, b. China, 1961). Ink and acrylic on Xuan paper. *Asian Art Museum of San Francisco, Museum purchase with exchange funds from the estate of K. Hart Smith with additional funds from the Clarence Shangraw Memorial*, 2012.5. © Zheng Chongbin. Photograph © Asian Art Museum.

FIG 4: Installation view of *White Ink* at the Chinese Culture Center of San Francisco. © Zheng Chongbin. Photograph © Chinese Culture Center of San Francisco.

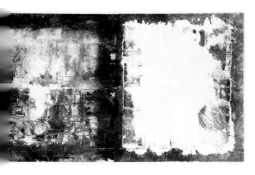

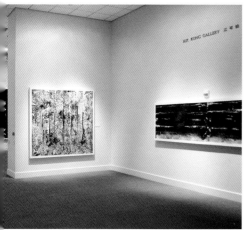

exploring inner space in a psychological way. Then, I shifted to the basic physicality of materials. Now I want to reconstruct how we perceive the world. ... For example, when I work on a pure acrylic surface, and the acrylic is reflective, it becomes part of the environment.

Since 2011, my work has shifted from depicting my inner self within a frame and toward space—an architectural integration. In that sense, it has also extended to how work is viewed when moving, how it is engaged and seen from different positions. ...

My method of creating paintings became folding, cutting, and reassembling. The boundary between painting and sculpture is blurred, expanding my painting practice and setting the work into motion. When I think about the painting itself now, it's less about the hands-on brushstroke or expressive marks. ... It's more about how we engage, how things form themselves ... and how we actively reflect upon paintings within the space. ...

I never thought in this direction until I realized that the material has its own agencies. ... Rather than paint about something, I facilitate it. I have become absent from the work.[7]

Zheng Chongbin continues to mature as an artist by using painting as a means to return to and to depart from, but his work now exhibits an enlarged range, extending into experimenting with space, architecture, and perception. This shift also corresponds to his evolving relationship with the Asian Art Museum. *Zheng Chongbin: I Look for the Sky* represents a journey that began when *Ended Season* entered the museum collection almost ten years ago and now continues with his embrace of the architecture itself.

The Fluidity of Light and Space

By referencing the translucency of Bogart Court and Gae Aulenti's idea of "[creating] open space with natural daylight" in his installation *I Look for the Sky*, Zheng Chongbin believes he is furthering these concepts.[8] Thinking architecturally in his work grounded in Bogart Court, but through the lens of an artist, Zheng Chongbin hopes to invite visitors to be more intentional in the space, and to extend this awareness to their navigation of Osher Gallery:

To think architecturally is essential when I am making work for a new space, except that in the architects' domain, they have greater concerns for functionality and practicality.

My work is about translucency. To see the veiled become unveiled, the invisible become visible. ... To observe this will allow us to experience the space more freely and make this vastness seem graspable, whether from under, above, or in between. ... Every sheet of material used in the exhibition is transparent or semitransparent. The flow of light—both as a particle and as a structure—becomes an interchangeable mechanism that has to do with

experience and perception. The flow of light is physical, but it requires viewers to make an autonomous attempt with an autonomous mind.[9]

Zheng Chongbin draws parallels between how water is used in ink wash paintings and how energy circulates in space:

> When we engage with an ink-wash painting, how do we create a piece with actions that are temporal and in flux? ... Water moves on the paper not only horizontally, but also vertically—on, into, and underneath the surface. ... We are on a round planet; there is no flat place. There is no land and sky. It all depends on where we are standing. We are standing upright vertically, but actually, we are upside-down. When I look at an art piece, that piece is not a one-directional thing. It's actually formed by exchangeable dynamics in a fluid space.[10]

These notions of the flow of light and the fluidity of space influence the way that Zheng Chongbin shapes the viewer's experience of Bogart Court in *I Look for the Sky*:

> The work should not be seen separately from the entire space. How traffic flows, how people walk in, how they encounter the work. ... I am looking for ways that our responses to space can be influenced. The first consideration is that I'm not looking at a space as just a space, but as a living world. The "seeing" is continuously changing and becoming something new, reshaping the space.[11]

This idea of reshaping proposes a reimagination of the museum's public, non-gallery areas surrounding the highly controlled gallery environments that fulfill the mandates for the display of fragile and precious art objects. Museums have perceived spaces like Bogart Court more as inactive structures than sources of inspiration. The contrast between how these two kinds of spaces are utilized demonstrates the divide between the "living world" and the "museum world." *I Look for the Sky* combines the two with openness and transparency.

Collective Participation

With a similar kind of openness, Zheng Chongbin has gradually grown from a pure painter into what he calls "a field artist engaging with different people."[12] *Zheng Chongbin: I Look for The Sky* is grounded in his approach to abstract painting but expands to rethink how to engage the museum architecturally, historically, structurally, and experientially. As the content of the exhibition remained largely unknown until the works were fully realized, the Contemporary Art department at the Asian Art Museum worked closely with the artist in discussing his initial concepts, sketches, and grand vision; in testing material in his studio; and in joining his excitement of working on his first solo exhibition at a West Coast museum. The way his work has evolved over the past ten years and this exhibition's connection to the future of the Asian Art Museum has made Zheng Chongbin one of the core enablers of the museum's transformation.

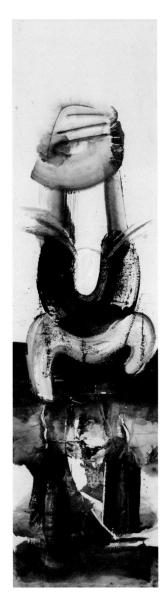

FIG 5: *Another State of Man No. 14*, 1987, by Zheng Chongbin (American, b. China, 1961). Ink and acrylic on Xuan paper. *Collection of the artist.* © Zheng Chongbin. Photograph © Ink Studio.

Endnotes

1 Thomas Christensen, ed., *Bridge to Understanding: The Art and Architecture of San Francisco's Asian Art Museum—Chong-Moon Lee Center for Asian Art and Culture* (San Francisco: Asian Art Museum of San Francisco, 2003), 55.

2 Gae Aulenti, "Gae Aulenti on the Asian Art Museum," interview with Tim Hallman in ibid., 57.

3 Ibid., 57–58.

4 Ibid., 58.

5 *White Ink* was an installment in the Chinese Culture Center of San Francisco's XianRui Artist Excellence series, an exhibition program that served as a platform for US–based artists whose migration experiences had transformed their practices.

6 Abby Chen, "White Ink, The Artist Is Absent," in *White Ink* (San Francisco: Chinese Culture Foundation of San Francisco, 2011), 10–11.

7 Zheng Chongbin in discussion with the author, November 20, 2019.

8 Aulenti, "Gae Aulenti on the Asian Art Museum," 58.

9 Zheng Chongbin, discussion.

10 Ibid.

11 Ibid.

12 Ibid.

13 Zheng Chongbin's practice after 2011 has been influenced by the 1960s Light and Space movement in Southern California, taking particular inspiration from the artists Robert Irwin (b. 1928) and James Turrell (b. 1943). Zheng Chongbin often describes his installations as "light and space installations" as a result.

For every exhibition presented by the Asian Art Museum, whether it shows historical or contemporary work, the synergy generated by multiple departments always drives a successful outcome. The process of putting together this exhibition of brand-new works called into question many museum practices, from label writing to registering artworks still in progress, to conserving the artist's intentions. Even this publication used an alternative approach to production; it required rethinking how to create a catalogue for site-specific commissions, as publications are typically completed and released just before the exhibition opening date. The multidirectional dialogues motivated by the artist's inquiries are emblematic of what the Contemporary Art department at the Asian Art Museum strives to achieve: an institutional movement driven by artistic agency and collaborative production.

Will *Zheng Chongbin: I Look for the Sky* and the other projects by the Contemporary Art department join forces within and beyond the Asian Art Museum for a larger dialogue to facilitate new museum practices in the contexts of access, inclusion, and creative autonomy? From a curatorial standpoint, Zheng Chongbin's "light and space" installation, among other efforts, manifests fluidly across different materials and mediums that demonstrate how contemporary art challenges preconceived spatial and institutional hierarchies.[13] By prioritizing the voice of the artist, it is inevitable that such creative processes will intervene in and contest museum operations on a structural level, as well as with audience engagement and pedagogy on an external level.

How will those who are in different places—whether within the United States or across the Pacific—see the role of the Asian Art Museum in facilitating artistic production? This question is significant in the Bay Area, a center of innovative technology and a hub for generations of Asian immigrants. From the museum's home in San Francisco to places beyond its borders, the world is rapidly becoming more environmentally, economically, and politically polarized. However, museums should be relevant to all. We need to do more than just focus on the artwork itself. We need to encourage collective participation in art by learning and connecting to the world, the community, and the era at large.

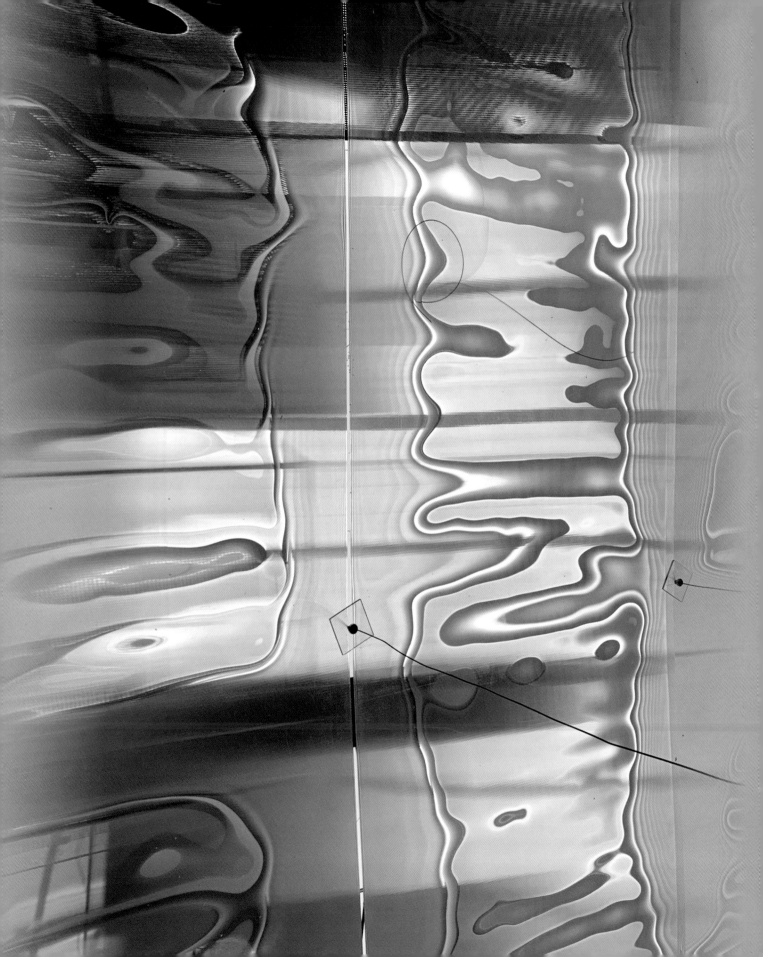

AS YOU LOOK TO THE SKY, THE ORDINARY BECOMES EXTRAORDINARY: ZHENG CHONGBIN'S DIFFRACTIVE HETEROTOPIA

MAYA KÓVSKAYA

The space in which we live, which draws us out of ourselves, in which the erosion of our lives, our time and our history occurs, the space that claws and gnaws at us, is also, in itself, a heterogeneous space. In other words, we do not live in a kind of void, inside of which we could place individuals and things. We do not live inside a void that could be colored with diverse shades of light, we live inside a set of relations that delineates sites which are irreducible to one another and absolutely not superimposable on one another. ... [They] have the curious property of being in relation with all the other sites, but in such a way as to suspect, neutralize, or invert the set of relations that they happen to designate, mirror, or reflect.

—Michel Foucault[1]

The Experiential Spaces of Zheng Chongbin

Iridescent patterns of shimmering, moving light catch our eyes as we enter the atrium of Johnson S. Bogart Court at the Asian Art Museum of San Francisco. Hanging near the skylights of the building, the immersive environmental installation by Bay Area–based artist Zheng Chongbin (b. 1961) offers an unexpected and playful encounter with the natural world. The artwork reveals our entanglement with the dynamic physical properties of nature. It poses a challenge to our basic understandings of the character of the nonhuman world and our relationship to the more-than-human.

These iridescent patterns suspended in space embody a series of virtual skies located within the airy interior of the museum's sky-lit atrium. And those skies can be regarded as what philosopher Michel Foucault (1926–1984) called a "heterotopia"—a place within a place, or site within a site, that mirrors yet troubles, turns upside down, or somehow transforms that which it mirrors.[2]

We will return to this idea later on and explore its implications in relation to a series of other critical concepts such as "diffraction"[3] and "intra-action"[4] from physicist and feminist philosopher of science Karen Barad's (b. 1956) "new materialism"[5] that we will encounter as we explore the mutual entanglements of the world of matter with the human and the more-than-human condition at play in Zheng Chongbin's newly commissioned site-specific work *I Look for the Sky*.

In the past decade, Zheng Chongbin has become well known not only for his painting practice, but also for his immersive environmental installations that tether art to science and the philosophy of science. His works draw their genealogy from strands of influence as diverse as California's Light and Space movement, experimental video art, and traditional Chinese ink painting. Noteworthy examples of work in this vein of his practice include the environmental video installation, *Chimeric Landscape* (2015–16); the architectural and painting installation *Wall of Skies* (2015); the light and space video installation *Walking Penumbra* (2018); and the site-specific light and space installation *Liquid Space* (2019). Each builds into a coherent trajectory of practice, actively engaged with the qualities of the materials performing their agential capacities captured in the work. This is particularly salient with regard to their intensive physical properties and homologous forms—especially fractal, wave, and rhizomatic forms—found across an astonishing variety of natural phenomena and entities.

This preoccupation with material agency seen in his light-and-space, architectural, and video installation work first emerged from his painting practice. Since his early experiments in nongestural painting, Zheng Chongbin has been creating distinctive artworks, using ink and acrylic, that feature repeating and homologous fractal forms. He has conjured up these forms without ever resorting to representational depiction. Instead, he has purposefully collaborated with the materials that he uses performatively, such as ink, water, acrylic, and Xuan paper.

After learning about the dynamic characteristics of his materials' intensive physical properties and behaviors, he began crafting sites, spaces, and conditions conducive for them to behave according to their natures within those contexts. He became adept at facilitating the unfurling of those materials' agential capacities to bring out the repertoire of naturally occurring forms that appear throughout the body of his work—forms that he conjures up not by depicting them representationally, but by allowing his materials to produce those forms themselves.

After years of this kind of painting, Zheng Chongbin returned to his background in video art and began to extend his collaborative engagement with materiality itself to create a series of perceptual, material mise-en-scènes—heterotopic experiential spaces within and yet distinct from the larger spaces to which they are related. Into these spaces he invites viewers, offering them the opportunity to playfully explore their own entanglements with the agency of the natural, physical world, through the material agency at play in the work. He does so in such a way that the artwork both activates and transcends its own material composition, becoming instantiated in the form of the viewers' embodied aesthetic experiences.

Diffraction

The material components that Zheng Chongbin installed in the atrium skylight of the Asian Art Museum, like those in his previous immersive works, are only a precursor to the full realization of the artwork. In other words, the heterotopic whole is more than the sum of its material parts. Although more than mere vehicle, the sculptural elements of the hanging installation embody aesthetic properties that activate, infuse, and surpass their evident human design.

As you approach the artwork, the rectilinear, humanly designed structure comes alive with the subtle shimmer of dancing, prismatic, rainbow-suffused designs made by nature—designs that recall taffeta, the patterns of an oil slick spreading across a puddle, the waving lines that emerge when light hits a screen, or the multicolored movement across the surface of a CD. The billowing, iridescent patterns morph even as you watch, shifting shape with each breath or movement of your head or even the flick of your eyes. The patterns undulate like gentle waves and move with you, as if in a dance, directed by your body. Raise your eyes, close them. Open them again and turn side to side. Lie on your back on the floor if you like, or crane your neck. Every angle offers a new perceptual vista, and the translucent surface of the artwork is a swarm of delicate color and scintillating light in motion. New patterns flow while others ebb. They appear and disappear into each other as you walk through the space beneath them, taking in the installation, activating it with your gaze. These are not the ostentatious rainbows of unicorns and glitter, but something more delicate and subtle.

These patterns you see are produced by a process called *diffraction* that pertains to phenomena that exhibit the behavior of waves. In the seventeenth century, Francesco Grimaldi (1618–1663) pioneered the field of optics, experimenting with the way light moved around or through boundaries, challenging the "corpuscular theory of light" that had dominated the field. Discovering that light acts like fluid when it encounters a barrier, "break[ing] up and mov[ing] outwards in different directions, Grimaldi dubbed this phenomenon *diffraction,* citing the Latin verb *diffringere—dis (apart)* and *frangere (break)."*[6]

Optical diffraction occurs when light moves around obstacles or passes through multiple apertures, creating many radiating wave patterns (similar to the pattern of the Wi-Fi icon, which also represents waves). As the flows of multiple waves encounter one another, overlapping, they form an interference pattern. Diffraction occurs in wave behaviors of water as well, such as when a river flow moves around rocks, when overlapping wakes of multiple boats produce interference patterns, or when stones are dropped into water and create series of outward radiating rings that interfere with one another and create a diffraction pattern. Diffraction also develops with sound waves as they move around physical barriers, and with other phenomena.

As the natural light that pours through the Bogart Court skylights bathes you—and you move your head, your body, and your eyes—diffraction patterns appear in the waves of subtle iridescence (waves that respond to your movements) in the heterotopic skies of the installation above you. And so this formerly underutilized rectangle of sky-lit space—a space that you normally ignore on your way between the museum's exhibition halls—comes to life as a heterotopic site—a place within a place that both mirrors and troubles that mirror image; a space containing multiplicities. Here human and more-than-human agency meet and make diffraction patterns that engender something both more beautiful and profound than what appears superficially to be the totality of the artwork.

So what is the nature of this site-specific artwork that Zheng Chongbin has made with *I Look for the Sky*? What is its ontological and categorical status? Is it a sculpture? An installation? Or is it something much more than any of those familiar categories of art object? And how do you know what it is—that is, what are the epistemological criteria for ascertaining the boundaries and shape of this artwork? While it may resemble a sculpture or an installation piece, to confuse the work with a species of aesthetic object that you typically associate with artworks would be a mistake.

At first glance, you indeed may suppose that the installation's scaffolding, overlaid with delicate screens and scored, grooved sheets of plastic film and acrylic, is itself the artwork. Yet this is not a wholly accurate description; it would be akin to confusing the physical apparatus of a movie theater—the architectural space in which you sit—with the movie you watch in that space. However, unlike a film

that is screened for an audience, which repeats for each viewer at each screening in exactly the same way, the "movie" here is unique to each person who sees it. There is no beginning, no end, no narrative or plot, and yet there is non-kinetic, almost Zen-like, meditative action contained within the appearance of stillness, dynamism within the frame of something you expect to be static. There is a deeper meaning that unifies the viewing experience nonetheless, just as there is systematic similarity in the visual quality of the aesthetic experiences each viewer will have—experiences that while similar in form are nevertheless unique.

Intra-action

To understand the deeper meaning of this artwork, you must also understand that you are a collaborator, rather than a passive recipient partaking in the consumption of preformed content. But what does this actually mean? What, then, is the artwork in question and how does your perceptual engagement with it intra-actionally help to constitute the work?

Karen Barad offers insights that help answer these questions. She has written extensively about intra-action, which she defines as an inseparable, entangled relationality.[7] Barad posits that *being* is, in part, a function of *co-becoming* through that relationality.[8] Phenomena and entities do not preexist their entanglement with one another, but rather they emerge through the multiple modes of relationality in which they are entangled. This *intra-action* is distinct from *interaction*, which assumes that agents have an integral discreteness and constitutive completeness, and that these ontologically discrete agents engage in some action together. With intra-action, agents are constituted in part through encountering one another. Intra-action, then, is by definition a mutually constitutive relationship.[9]

If you focus on the dynamic intra-action in *I Look for the Sky*, you can see how the separation of the ontological from the epistemological question is misguided. That is, you cannot know *what* a thing is separately from *how* you know what it is. Intra-action takes the philosophical stance that engagement and relationality among physical components shape all parties. Thus, the dynamic physics of the artwork's materials—including the light waves pouring down from the actual skies that house the virtual, heterotopic skies, the physical laws and chemical compositions that govern how the various materials in the work behave, the way the cones in your eyes capture and process light, and your changing stances as you activate the work with your body—are mutually constitutive of the artwork.

This means that with each encounter with this artwork, the shape of what you see, experience, and participate in making is constantly being formed, reformed, constituted, and reconstituted through the dynamic intra-actional engagements among you, the materials, the light, and the aparatus installed by the artist. And each viewing also alters you, changes your understanding of yourself in relation

to the world, as the world (or the parts of it activated through the work, light, material, space, motion, etc.) shows you secrets of its inner workings.

The artwork *I Look for the Sky*, then, is an intra-actional relationality and the experiential, heterotopic space produced by that relationality. The physical components of the artwork, the structures in particular relations to one another, the physics of light, and the diffraction patterns that appear when your active eyes observe light passing through the myriad apertures in the structure together create the experiential phenomena of the artwork. At the same time this intra-actional relationality also provides the grounds for recognizing what the artwork actually is—where its boundaries lie as a heterotopic space within a space. The artwork, then, should not be understood as a passive, material, sculptural object, but rather as the experiential expression of these intra-active relationships that mutually shape one another.

Let us unpack what that entails and means. Artist, viewer, physics, photons, light waves, air, and various materials—such as the diffraction apertures created by the staggered alignment of perforations, grid of mesh, and grooves scored into plastic sheets—all intra-actionally combine with your physiology and your bodily and perceptual engagement to produce the phenomenologically contingent, individually unique, yet formally homologous, aesthetic experience that is the performative culmination and fulfillment of the artwork.

Your moves, mind, body, and active engagement intra-actionally combine with the agential qualities of light behaving as waves, and expressed through activated characteristics of the material, diffracting into iridescent patterns of interference. Hence ontology is not represented, but rather it is enacted, performed, and embodied. The work does not represent an encounter by ontologically discrete and separate individuals with ontologically discrete and separate natural phenomena. It embodies that encounter, it is that encounter, and the encounter shapes those elements of the encounter simultaneously and dialogically due to our mutual entanglements with the physical world and that world with us. In this way, you and the work transform one another through the encounter, and so the work is remade over and over as it is instantiated again and again in the form taken in each aesthetic experience of the work.

Active Engagement

In her theoretical work, Karen Barad extends the implications of quantum entanglement into other domains of being and knowing, such as the philosophy of science. The intra-active, mutually constitutive, transformative character of entanglement, she writes, refutes the possibility of a dichotomous, binary boundary between subject and object, between the knower and the known. *How* you know changes *what* is known and knowable. By the same token, what and how you know changes you.

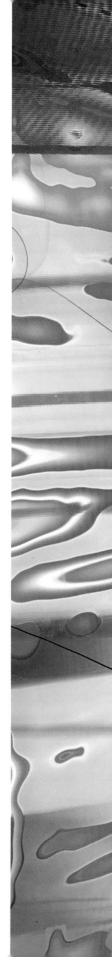

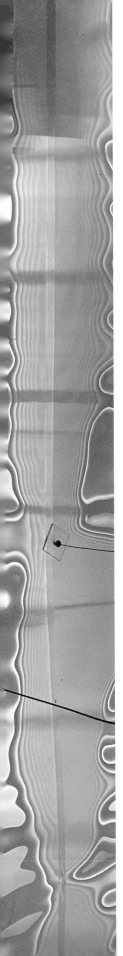

To understand the context for Barad's broadly applicable, lucid insights, it is helpful to look at the debates between Albert Einstein (1879–1955) and Niels Bohr (1885–1962) that she draws on. These debates concerned whether light was indeed a particle, as Isaac Newton (1643–1727) and classical mechanics held, or a wave, as Thomas Young (1773–1829) had demonstrated through his famous double-slit experiments in 1803. Bohr argued that under conditions of uncertainty as to which of two available slits the light photons would pass through, light would behave like a wave, while under conditions in which the observer could track the path of the photons by installing a "which-path detector," light would act like a particle.[10] What's most important here is that his theory upended the paradigm of classical Newtonian physics by contending that our actions of observing and measuring the behavior of light changed that behavior. In other words, knowing and being are intra-actively, and hence onto-epistemologically, entangled and mutually constituting.

This insight helps highlight how the artwork is constituted with you, the viewer, as participant and collaborator. The hanging geometric frames of *I Look for the Sky* scaffold the perforated screens and transparent films, scored with innumerable thin lines, like the grooves of an old vinyl record. These grooves and nets form a diffraction grid. That grid filters light through myriad tiny apertures. Light traverses those apertures on its way from the actual sky through the heterotopic skies embodied in Zheng Chongbin's installation. The assemblage of photoreceptor cells (rods and cones) in your eyes converts certain specific wavelengths of light into information in your brain. If vision is facilitated by your perception of light, color is experienced as different wavelengths of light mediated by the spectral sensitivities and ratio of the cones, specific to your particular eye physiology. This is one of the reasons that color perception is more experientially subjective than externally objective, varying across a population. (Colorblindness is a function of this variation.) I offer a scientific explanation:

> Unlike rods, which contain a single photopigment, there are three types of cones that differ in the photopigment they contain. Each of these photopigments has a different sensitivity to light of different wavelengths, and for this reason are referred to as "blue," "green," and "red," or, more appropriately, short (S), medium (M), and long (L) wavelength cones, terms that more or less describe their spectral sensitivities. ... This nomenclature implies that individual cones provide color information for the wavelength of light that excites them best.[11]

The physiology of your eye and brain, together with wavelengths of light, determine the way color appears. The barriers that light goes around and the apertures that light passes through, as well as the iris itself, all make diffraction patterns. Your bodily encounters with light and color, wave interferences, and diffraction patterns all play a role, then, in activating the installation and constituting the power of the work as a whole. While the artwork is obviously not a

physics experiment to discern whether light is behaving as particle or wave, in a sense it is not wholly unlike the double-slit experiment in that the observer/viewer is an entangled participant and collaborator in shaping the aesthetic experience that is the artwork.

Zheng Chongbin has deftly crafted an artwork, then, that finds its iterative completion at the nexus point of your bodily experience and the aparatus of the installation with the dynamic agency of the physics of light diffraction. Every view reconstitutes the artwork, and thus it is iteratively produced again and again at each viewing, as the work is completed anew by each viewer. Your bodily encounter with the installation takes an aesthetic form that the artist has called into being by setting an experiential stage for its emergence. In other words, the work does not merely comprise the physical objects that make up the installation that is hung there, but, more importantly, the work inheres in the aesthetic experience produced through the multifaceted collaboration between artist, audience, the physical apparatus (diffraction grid and other elements of the hanging installation), the agential properties of the natural physical world, and the behavior of light undergoing diffraction.

Through your active engagement with (rather than passive consumption of) the site-specific installation and the natural processes flowing through the space, you are offered the opportunity for a self-reflective embodied experience of the process of entanglement between your own agency as a viewer and specific agential capacities of the nonhuman, material world. These multiple expressions of agency act together to produce the conditions for this particular sort of aesthetic encounter. Through your engagement with the installation, you are offered a chance to sense your dynamic connection to a resonant universe replete with myriad forms of emergent, dynamic, nonlinear systems, and forms of agency with which all of us humans are always entangled as we make our shared world.

Yet because of the way in which ideologies of human agency have been overvalorized since the Enlightenment, many of us humans (particularly modern, Western humans) rarely see the world outside of ourselves as possessing and enacting agential qualities. It is no coincidence that the dominant Enlightenment ideology projects humans as godlike actors in a world of passive, mute material over which we strive (as self-proclaimed standard-bearers of our actually far more heterogeneous species) to exert ultimate control and dominion. This ideology of human ontological separateness from and dominance over the natural world has led to vast anthropogenic processes of systemic interference in the planet's physical life support systems, upon which we sometimes forget that we all irreducibly depend. Intra-action and diffraction remind us that we are entangled in a dynamic universe that is, as Karen Barad implies, always meeting us halfway.

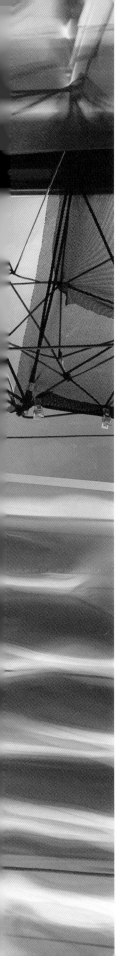

Diffractive Heterotopia

Now let me return to Foucault's concept of heterotopia, introduced at the beginning of this text. Zheng Chongbin's artwork functions as a kind of heterotopic site. Heterotopias are related to yet differ from utopias, which are "sites with no real place," that is, "sites that have a general relation of direct or inverted analogy with the real space of Society. [Utopias] present society itself in a perfected form, or else society turned upside down ... [they] are fundamentally unreal spaces."[12] Dystopias are the nightmare versions of utopias—also "ideal typical" notions rather than real spaces.[13]

The heterotopic site, however, is "defined by relations of proximity between points or elements."[14] Foucault's interest lies in the function performed by these sites that exist in relation to other sites or spaces, "but in such a way as to suspect, neutralize, or invert the set of relations that they happen to designate, mirror, or reflect."[15] Foucault explains that "the mirror is ... a heterotopia in so far as the mirror does exist in reality, where it exerts a sort of counteraction on the position that I occupy." It does so, he argues, by functioning as "a sort of shadow that gives my own visibility to myself, that enables me to see myself there where I am absent." Foucault further expands:

> Starting from this gaze that is, as it were, directed toward me, from the ground of this virtual space that is on the other side of the glass, I come back toward myself; I begin again to direct my eyes toward myself and to reconstitute myself there where I am. The mirror functions as a heterotopia in this respect: it makes this place that I occupy at the moment when I look at myself in the glass at once absolutely real, connected with all the space that surrounds it, and absolutely unreal, since in order to be perceived it has to pass through this virtual point which is over there.[16]

As useful as the concept of heterotopia is, the metaphor of the mirror that Foucault uses to help explain the concept has its limitations. The metaphor of heterotopia as mirror is problematic in the way that it is framed by a language of optics, particularly that of illumination, rooted in the Enlightenment assumption that there exists a fixed and given, unitary, objective truth that can be ultimately known. The "light" in Enlightenment harkens back to Plato's (approx. 429–347 BCE) distorted shadows cast on the walls of the proverbial cave and the idea of unmediated light as access to knowledge of the true forms of things. In this ideology, light is the means to truth, and knowledge is an ideational reflection of a presumed, external bedrock reality that objectively exists entirely outside of human perception and consciousness.

This ideology is present in the widely shared, positivist discourse about truth-functionality, ontology (being), epistemology (knowing), and their relationships to one another that has dominated Western thought from Plato through René Descartes (1596–1650) and continues in the mainstream positivist thought

of our present. Foucault's work on being and knowing explored the genealogies and the discursive conditions of both. Yet the troubling implications and assumptions necessarily bundled into the mirror metaphor, which shapes, in part, how heterotopia as a concept is understood, unwittingly burdens that concept with ontological and epistemological baggage from the Enlightenment that Foucault struggled to deconstruct.

Like the thought of many other feminist and poststructuralist thinkers, Donna Haraway's (b. 1944) feminist, posthumanist philosophy of science challenges the dominant Enlightenment ideology that posits a neat separation between being and knowing.[17] She rejects the trope of unmediated light as the way to see a separate bedrock reality that can be objectively mirrored in knowledge. She rejects the idea of knowledge as a mirror-like reflection of an external objective reality that is also presumed to be independent of that knowledge. To help us see differently, Haraway changes the framing device, substituting the metaphor of reflection with the metaphor of diffraction that I discussed at length above. She does so in ways that Foucault might have celebrated but did not quite manage to articulate as coherently in his writings on heterotopia.

Karen Barad's writings on onto-epistemology takes the entanglement of our theories of being and theories of knowing a step further. She extrapolates the actual (rather than metaphorical) process of diffraction from her work in theoretical physics, and she shares Haraway's extended use of the concept as a way to read various forms of difference through one another, diffractively. Barad explores the emergent interference patterns without eliding the underlying differences that produce those patterns.[18]

While neither Barad nor Haraway, to my knowledge, draw on the concept of heterotopia, applying the onto-epistemological frames from their work using diffraction to heterotopia, frees that Foucauldian concept from the frames that kept it trapped in an outdated Englightenment discourse of sight, light, truth, and reality in relation to being and knowing—hence Barad's new materialist, or agential realist, fusion of ontology and epistemology in a mobius-strip-like intra-actional relationship. In other words, while Foucault's mirror heterotopia reflects only one inverted, displaced image at a time, a diffractive heterotopia contains mutually entangled, simultaneously coexisting multiplicities.

Diffraction gives us more conceptual traction than reflection, Haraway argues, because,

> Diffraction does not produce "the same" displaced, as reflection and refraction do. Diffraction is a mapping of interference, not of replication, reflection, or reproduction. A diffraction pattern does not map where differences appear, but, rather, maps where the effects of differences appear.[19]

Diffraction patterns, she tells us, "record the history of interaction, interference, reinforcement, difference." What is important here is that "diffraction is

about heterogeneous history, not about originals." This diverges from the mirror model because, "unlike reflections, diffractions do not displace the same elsewhere, in more or less distorted form." Instead, Haraway reasons, "diffraction can be a metaphor for another kind of critical consciousness."[20]

For this reason, to call Zheng Chongbin's *I Look for the Sky* a diffractive heterotopia is to characterize it by its onto-epistemologically entangled multiplicities. This artwork, then, is neither a spotlight to shine down on a putative truth that independently exists outside of ourselves, nor is it a nod to solipsism. It is a space in which, however briefly, we can meet the universe halfway. By seeing the diffraction patterns of our entanglements with that mattering universe, we may come to know a very different sort of truth altogether. Moreover, because the artwork requires our embodied experiences for its fulfillment, we must also experience that truth with our bodies, not merely as remote, intellectualized abstraction.

Collaboratively produced and iteratively experienced by numerous museum-goers, *I Look for the Sky* does its most important diffractive work through the experiential form taken by these ongoing intra-active dynamic relationships across the human and more-than-human world. With his intimate understanding of the workings of diffraction, Zheng Chongbin has carefully set the stage so that you become participants in collaboration with agential forces in nature to co-enact a unique aesthetic experience. This experience is the essence of the artwork and a reminder of the extraordinary nature of seemingly ordinary processes of the physical universe all around us—extraordinary nature to which we modern, Western human beings have long been far too oblivious or inured.

Reclaiming Entanglement

The idea of heterotopia applied to the virtual space within a real space created in Zheng Chongbin's site-specific work allows us to consider how an encounter with this heterotopic space opened up through the work allows us, as viewers and participants, to see ourselves through the artwork in a different way—a way that changes us. To see our world as one that we collaboratively make together with the various agential forces of the universe, which in turn affect us even as we are affecting them—rather than alone, as godlike creatures molding the inert clay of existence in the images of our desires, and for our purposes—is to recognize a world shaped by diffraction, shaped by the interference patterns created by myriad agents working together, with and against one another.

Imagine the diffractive power of seeing ourselves knocked off that pedestal of our imagined human supremacy—our godlike sovereign agency. How might it help us to see ourselves anew if we could see, through this diffractive heterotopia, ourselves displaced (even momentarily) from the role enshrined in our dominant Enlightenment ideology? That ideology tells us that we humans alone possess agency, that we alone make the world meaningful, that we alone have the

exceptionalist power to dispose of and do with the world (and all that is within it) as we please, even at risk of exploitation, extraction, extinction, eradication, or erasure of whole tracts of the natural world.

Embodied experiences of this artwork that is a diffractive heterotopia can allow us to see ourselves, not as the same but displaced as in Foucault's mirror-image heterotopia, but as part of a heterotopia of diffractive mappings of our entangled heterogeneous, multivalent, shared existence. Such an experience need not be primarily cerebral. To experience how each of us can make light move into iridescent wave patterns by intra-acting with it is a physical experience that offers a physical, embodied, felt knowledge of our mortal, not just mental, connection to the material world through our material and mortal bodies—bodies that can see light; sense motion; perceive beauty; feel pleasure, awe, curiosity, and delight; and experience the sublime through our own flesh. As we take in the shifting iridescent diffraction patterns moving with our bodies and eyes, bathed in subtle light in motion, and we realize that those patterns dance with us, this artwork allows us to encounter the physical universe with both our bodies and our minds in a way that can bring us back experientially, even if only momentarily, to a ludic, childlike moment of unmediated connection with the workings of the natural world. In doing so, it can revitalize our connection with this more-than-human world.

From this modest starting point, we can begin to pay more attention to how our world is intra-actively constituted with each of us tangled up inextricably in it. We see that there is no conceivable "us" apart from that world, and that the same world is also profoundly shaped by us. And these simple, embodied, experiential epiphanies can be a first step toward relativizing the ideology of human supremacy that is driving ecocidal destruction of our physical world.

Zheng Chongbin's *I Look for the Sky* offers a much-needed reminder of what we instinctively know with our material bodies but unlearn through countless social and discursive technologies designed to disconnect us (in our minds at least) and reinforce our supposedly rightful dominance over the natural world. They remind us that we are part of a much bigger, more complex, dynamic, and, most importantly, shared universe that talks back to us all the time. The world certainly has been talking back to us in response to the dramatic effects caused by our dominant way of life. After all, what else is climate change but a direct response on the part of our planetary life-support systems to the havoc of the Anthropocene (the so-called new geological Age of Man) that Western, modern humans set in motion? But we are so slow in learning to read that writing on the wall. Perhaps, in its own way, art that can help each of us to recover an embodied, personal sense of the reality of our entanglement with the material world we share with the more-than-human universe can also help us recognize the gravity of that entanglement as well.

Endnotes

1 Michel Foucault, "Of Other Spaces," trans. Jay Miskowiec, *Diacritics* 16, no. 1 (Spring 1986): 23–24.
2 Ibid, 22–27.
3 Donna Haraway, "The Promises of Monsters: A Regenerative Politics for Inappropriate/d Others," in *Cultural Studies*, ed. Lawrence Grossberg, Cary Nelson, and Paula Treichler (New York: Routledge, 1992), 299–300. See also Donna J. Haraway, *Simians, Cyborgs, and Women: The Reinvention of Nature* (New York: Routledge, 1991).
4 Karen Barad, "Intra-actions," interview with Adam Kleinman, *Mousse* 34 (2012): 76–81.
5 Karen Barad, *Meeting the Universe Halfway: Quantum Physics and the Entanglement of Matter and Meaning* (Durham, NC: Duke University Press, 2007).
6 Karen Barad, "Diffracting Diffraction: Cutting Together-Apart," in *Diffracted Worlds— Diffractive Readings: Onto-epistemologies and the Critical Humanities*, ed. Birgit M. Kaiser and Kathrin Thiele (London: Routledge, 2018), 6.
7 Karen Barad, "Posthumanist Performativity: Toward an Understanding of How Matter Comes to Matter," *Signs: Journal of Women in Culture and Society* 28, no. 3 (2003): 801–29.
8 Barad, *Meeting the Universe*, 106.
9 Ibid., 333.
10 Ibid., 71–94.
11 "Cones and Color Vision," in Dale Purves et al., eds. *Neuroscience*, 2nd ed. (Sunderland, MA: Sinauer Associates, 2001); https://www.ncbi.nlm.nih.gov/books/NBK11059/.
12 Foucault, "Of Other Spaces," 24.
13 Max Weber, *The Methodology of the Social Sciences*, trans. and ed. Edward A. Shils and Henry A. Finch (Glencoe, IL: The Free Press, 1949), 90–93. In Weber's words, an "ideal type is formed by the one-sided accentuation of one or more points of view and by the synthesis of a great many diffuse, discrete, more or less present and occasionally absent concrete individual phenomena, which are arranged according to those one-sidedly emphasized viewpoints into a unified analytical construct." Ibid., 90.
14 Foucault, "Of Other Spaces," 24.
15 Ibid., 23.
16 Ibid., 24.
17 Donna Haraway, "Situated Knowledges," in *Simians, Cyborgs, and Women*.
18 Barad, *Meeting the Universe*, 71–72.
19 Donna Haraway, "The Promises of Monsters: A Regenerative Politics for Inappropriate/d Others," in *Cultural Studies*, 300.
20 Donna Haraway, *Modest_Witness@Second_Millenium.FemaleMan©_Meets_OncoMouse™: Feminism and Technoscience* (New York and London: Routledge, 1997), 273.

I LOOK FOR

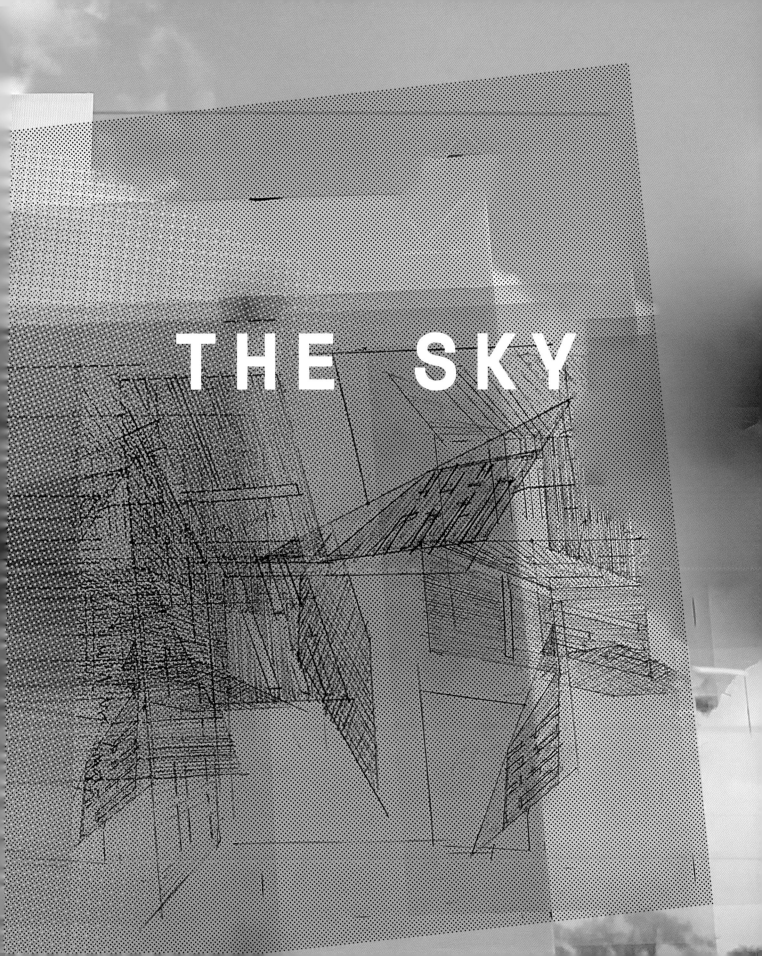

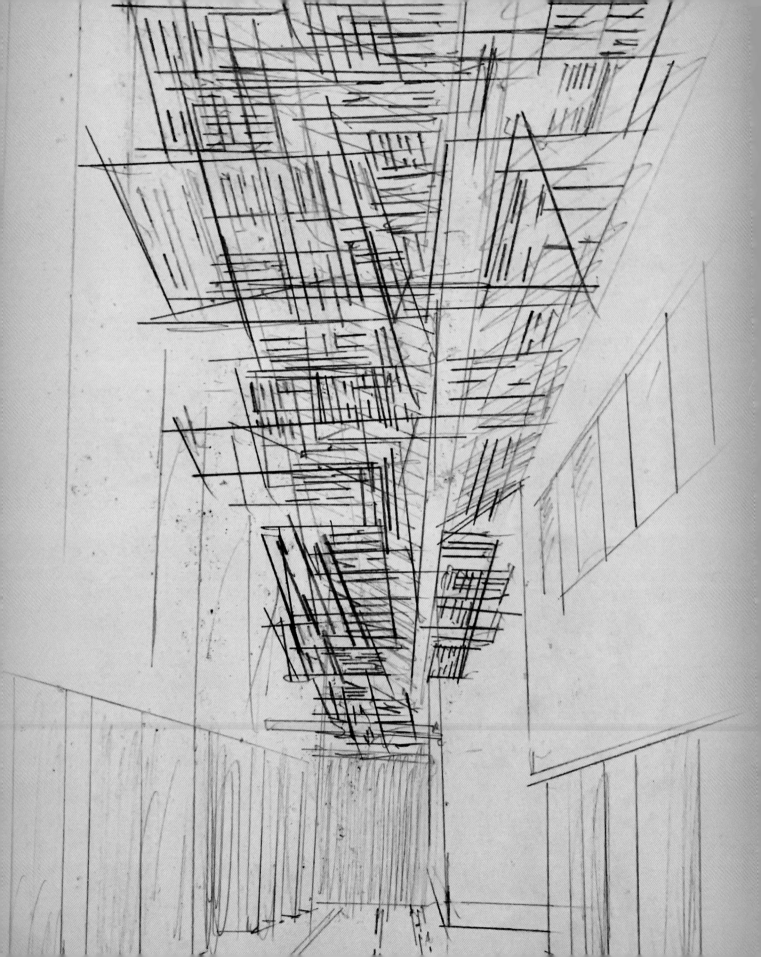

I LOOK FOR THE SKY, 2020

Zheng Chongbin (American, b. China, 1961)

Light-activated, site-specific installation with acrylic sheets, optical light film, and carbon fiber tubes

Commissioned by the Asian Art Museum of San Francisco, courtesy of the artist

Suspended beneath the skylights forming the high ceiling, *I Look for the Sky* brings together body and light to transform how the space of Johnson S. Bogart Court is experienced. The methodically engineered structure consists of a carbon fiber grid mounted with an array of staggered acrylic panels, which range from clear to opaque and feature small laser-cut holes that function as apertures. The underside of this layered, crystalline installation is veiled by translucent optical film sheets that create liquid-like light effects.

I Look for the Sky filters, warps, and refracts the sunlight overhead, creating a perceptual experience that changes depending on our own bodily movement and where we are positioned in this spacious entrance hall. The work hovers unevenly in relation to the surrounding architecture, reorienting the environment as an ephemeral site that invites us to embrace infinite flux, imagine the world anew, and develop original ways to engage familiar settings. In alignment with the Asian Art Museum's recent transformation—which aims to reinvigorate the visitor experience—the open-ended encounters enabled by *I Look for the Sky* serve to radically reimagine Bogart Court, activating a public common area that has been historically underutilized as a place to display artwork.

The expansiveness of *I Look for the Sky* reflects a similarly fluid approach to styles and influences. Zheng Chongbin is inspired by the Light and Space movement in postwar Southern California, in which artists directed light using industrial materials with unique optical properties. This installation also reflects his decades-long practice as a contemporary ink painter, evoking the layers and textures of diluted washes on delicate paper. By setting painting into motion, *I Look for the Sky* brings movement into the stillness of the space, in parallel with the artist's recent shift towards staging architectural interventions. The work also conceptually resonates with Italian architect Gae Aulenti's (1927–2012) visionary design of Bogart Court—part of the 2003 renovation of San Francisco's Main Public Library into the structure that the Asian Art Museum currently inhabits—which opened the entire building up to natural light.

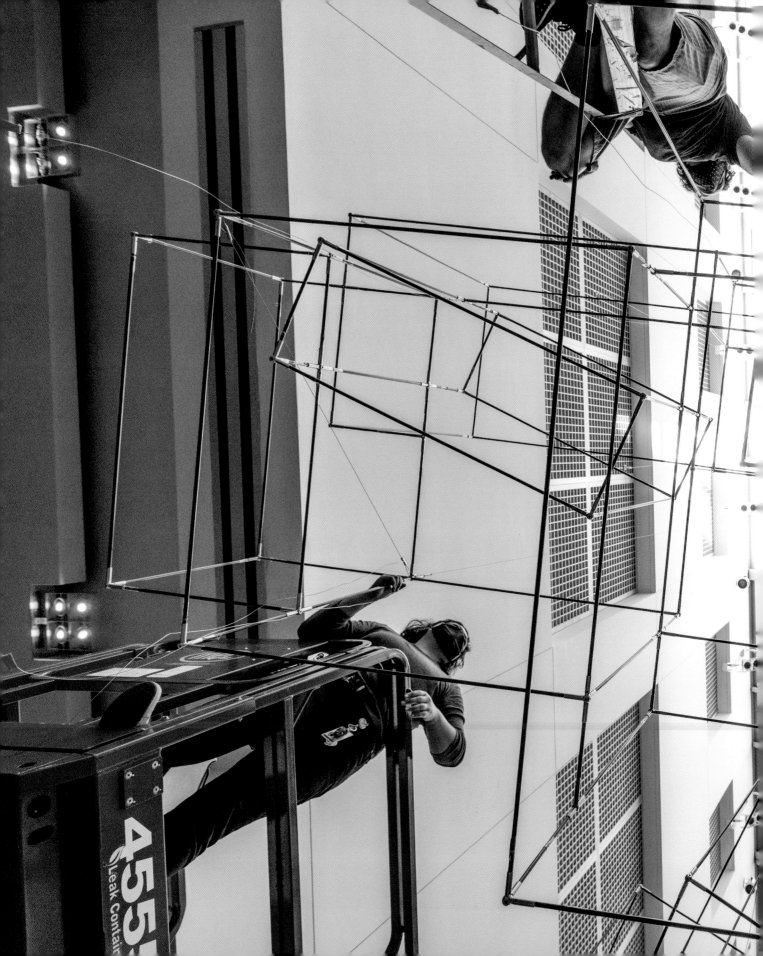

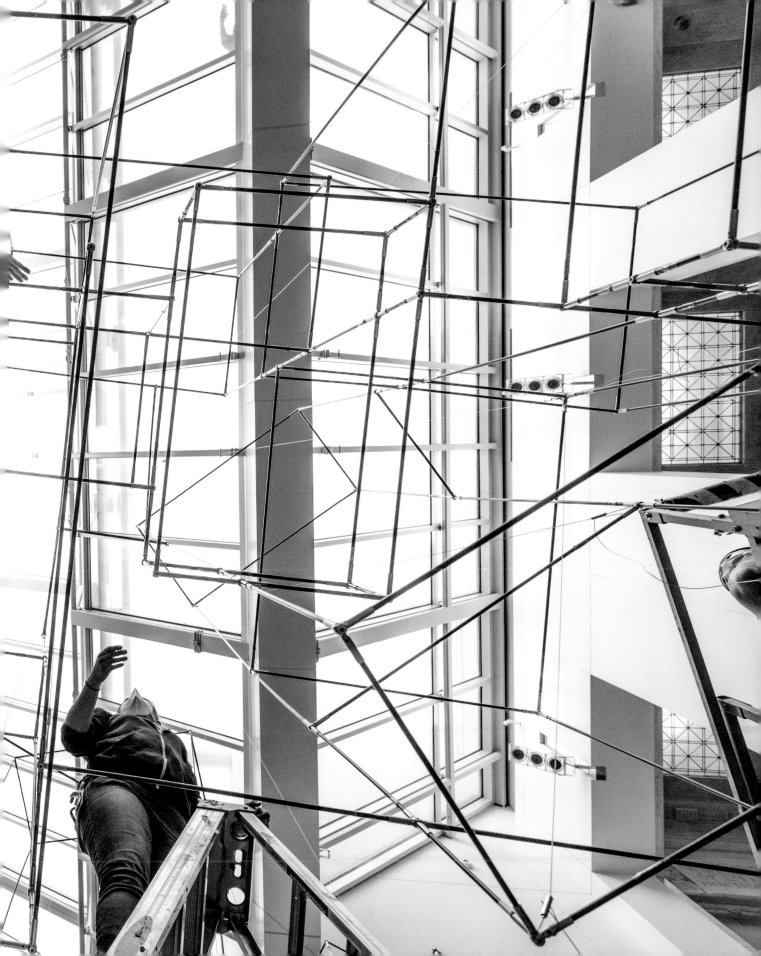

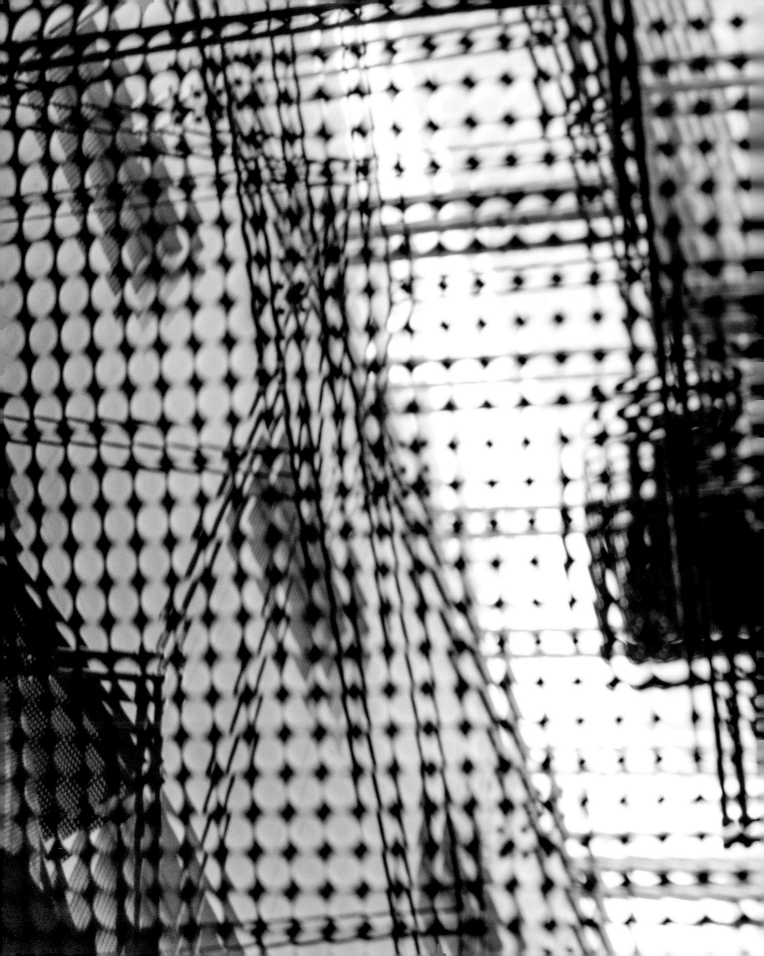

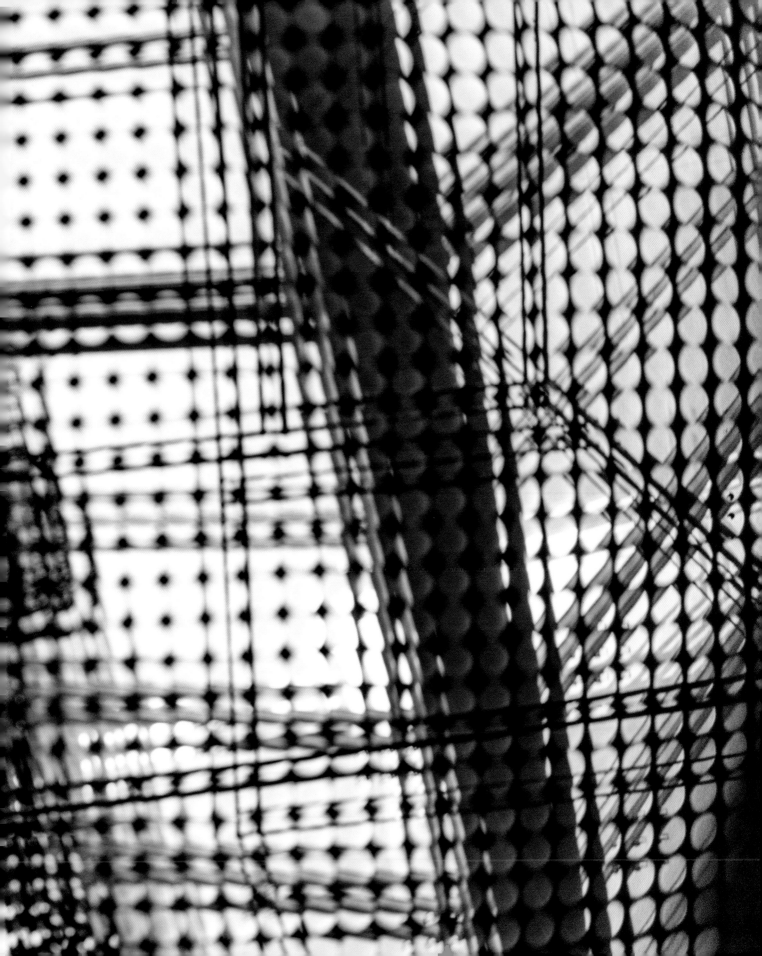

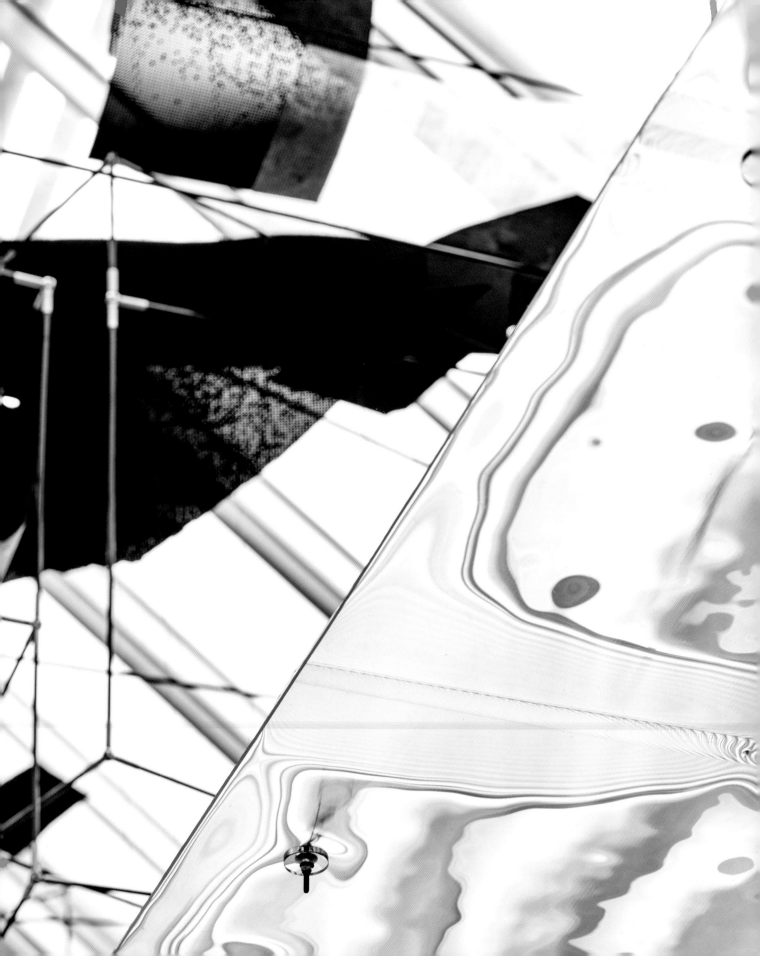

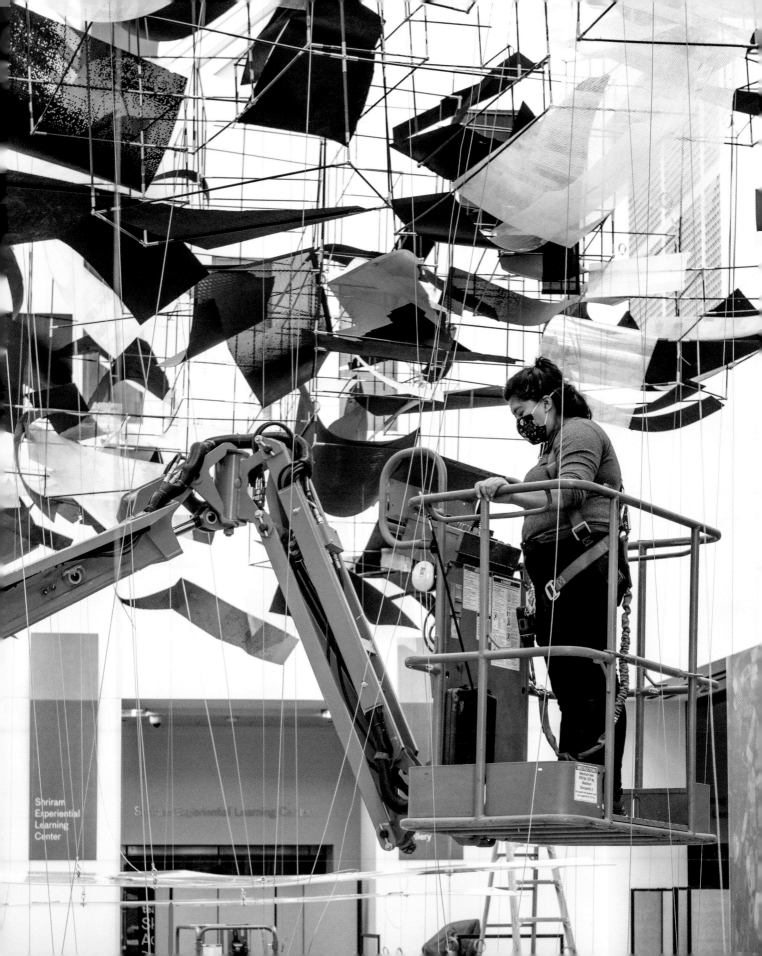

Cha May Ching
Museum Boutique

Exit Only

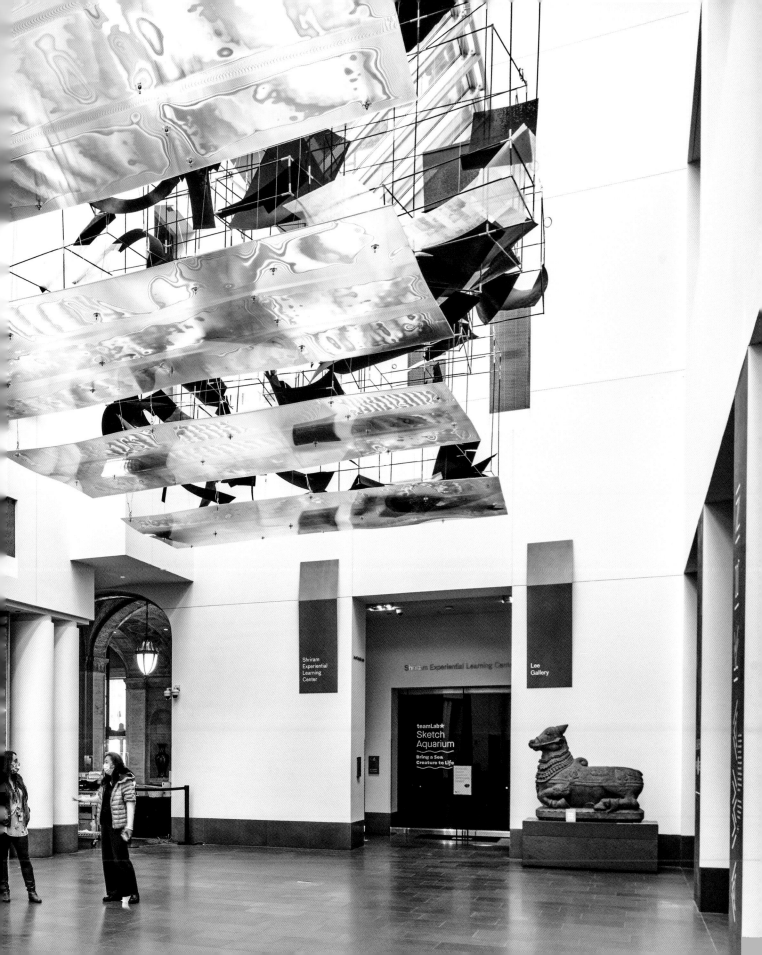

Shriram
Experiential
Learning
Center

Shriram Experiential Learning Center

Lee
Gallery

teamLab★
Sketch
Aquarium
Bring a Sea
Creature to Life

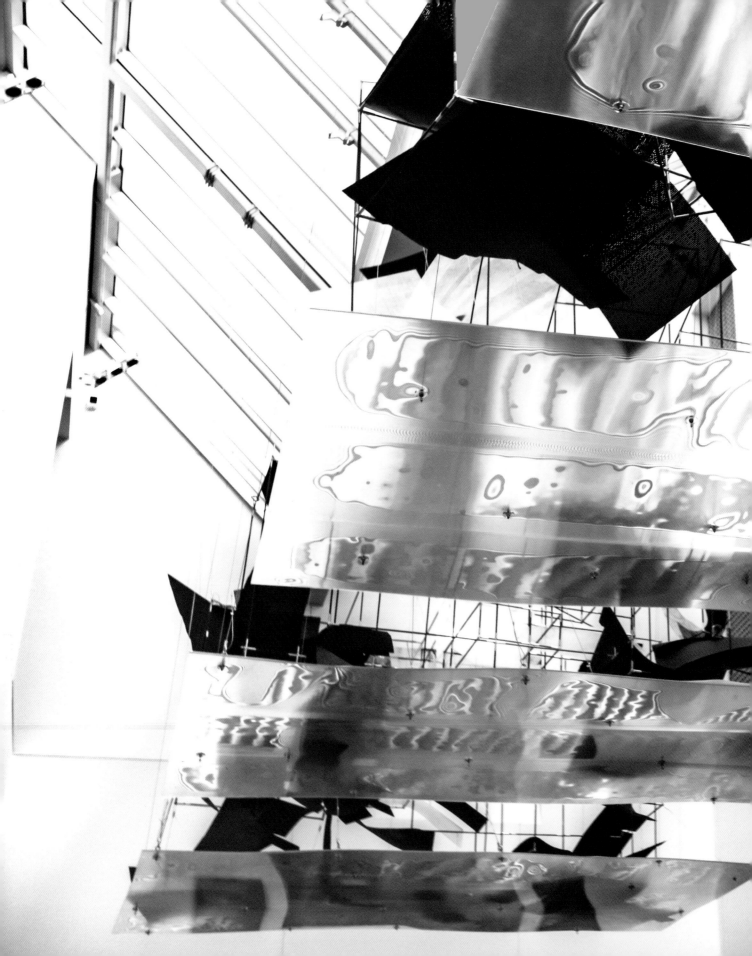

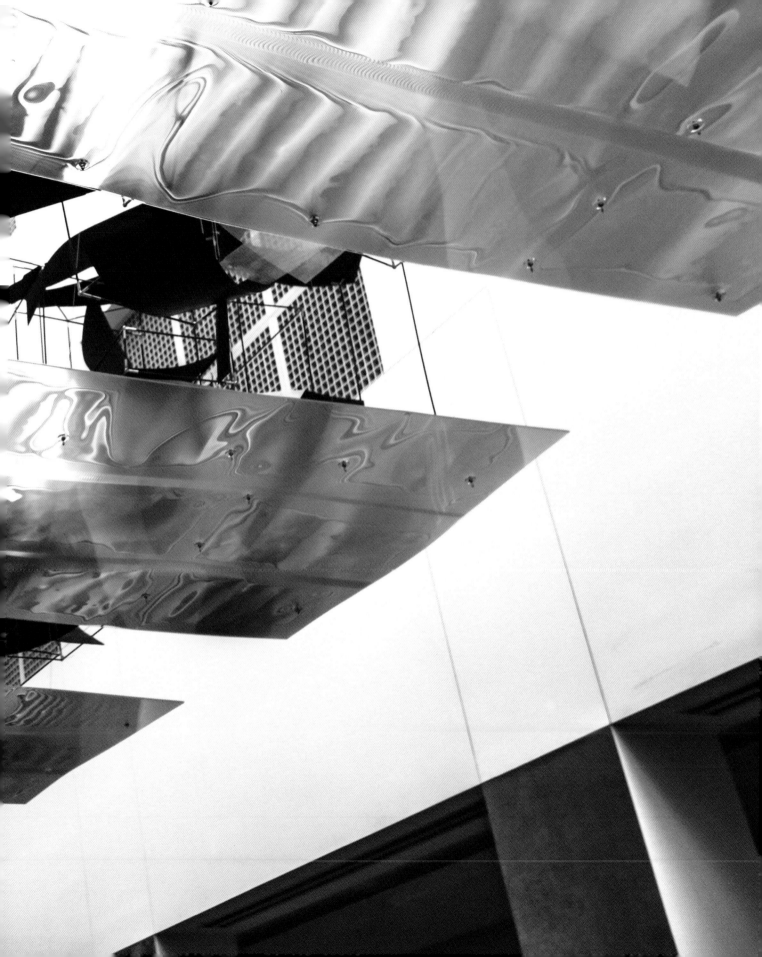

STATE OF

OSCILLATION

STATE OF OSCILLATION, 2020

Zheng Chongbin (American, b. China, 1961)

Site-specific installation with video, sound, paintings, drawings, and prints

Commissioned by the Asian Art Museum of San Francisco, courtesy of the artist

Departing from the bright natural light in Johnson S. Bogart Court, the neighboring Bernard Osher Foundation Gallery casts visitors into shadow with the multisensory installation *State of Oscillation*. The center of this dimly lit space features a light chamber made from scrim sheets. Within its translucent walls, ethereal, soft-focus videos from several projectors and ambient noise from a directional speaker immerse us in light and sound. The light projections also emanate from the chamber and illuminate various objects installed on the gallery perimeter. These include large-scale abstract ink paintings composed from hard-edged geometric planes and fluid washes, rendered in a lacquer-like pigment that subtly glistens in the light.

Filtering visitors' experience through shifting light projections, translucent screens, and a fluctuating soundtrack, the entire installation seems to change as we navigate the space. This constant motion, enabled by even the smallest shifts in perspective, gives *State of Oscillation* its title. Central to artist Zheng Chongbin's practice is the notion that the matter and energy comprising our world never cease their flow, even when organized into structures. The transient realm that envelops visitors in State of Oscillation then represents the dynamic universe, perpetually recreating itself. In this spirit of renewal, the installation also incorporates several existing works by Zheng Chongbin—including early concept drawings—which the installation bestows with new life.

State of Oscillation embodies the notion that everything is interconnected. Zheng Chongbin states that his intention with this installation is to draw out the soul of Osher Gallery, treating the space as a holistic being rather than a container for discrete works. As such, he describes the arrangement of objects in *State of Oscillation* as integrating individual elements into a larger system. In addition, the installation evokes both the macrocosmic and microcosmic, connecting worlds that are typically beyond our perception. Zheng Chongbin sources the videos and sounds in the work from his research on various systems, large and small—ranging from cellular to cosmological. Creating a celestial environment that responds to subtle movements, *State of Oscillation* stages an intimate yet transcendent experience that considers our place within the universe at large.

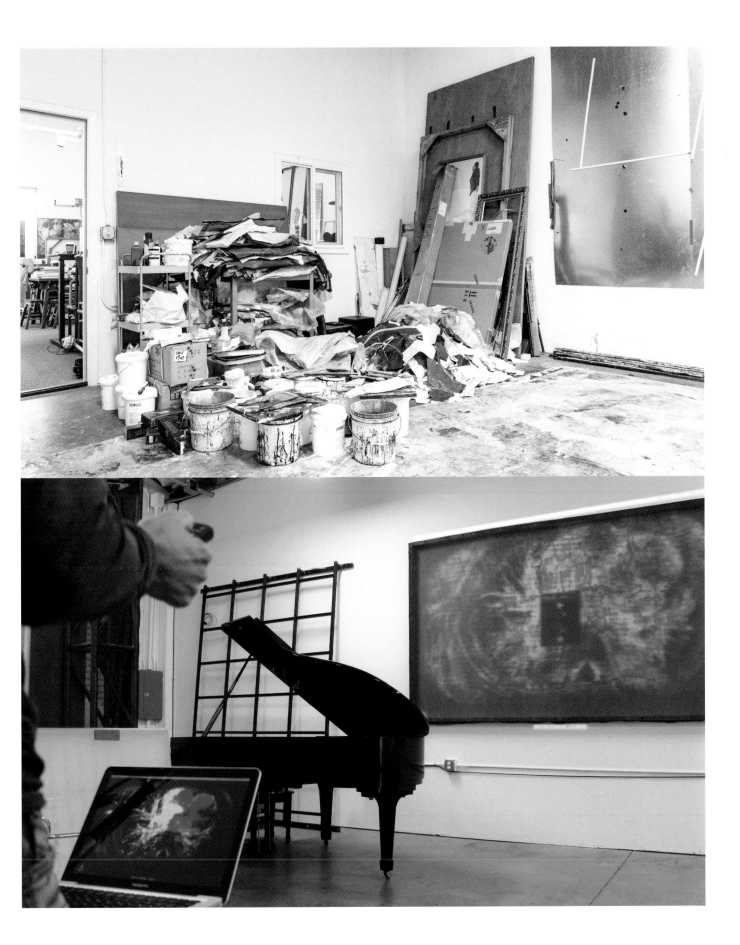

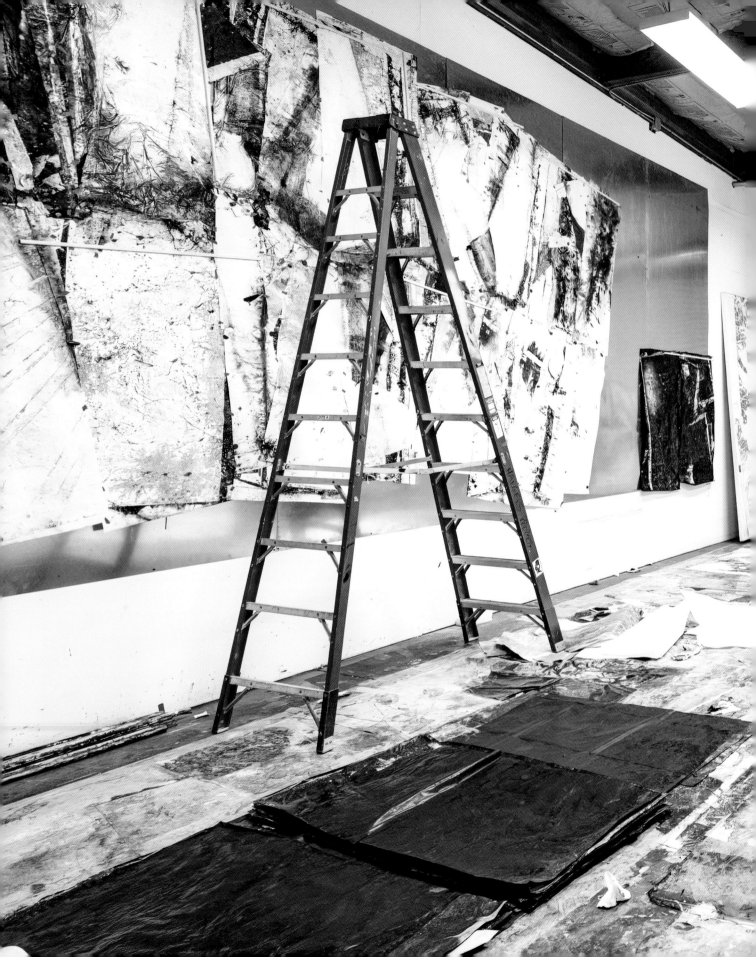

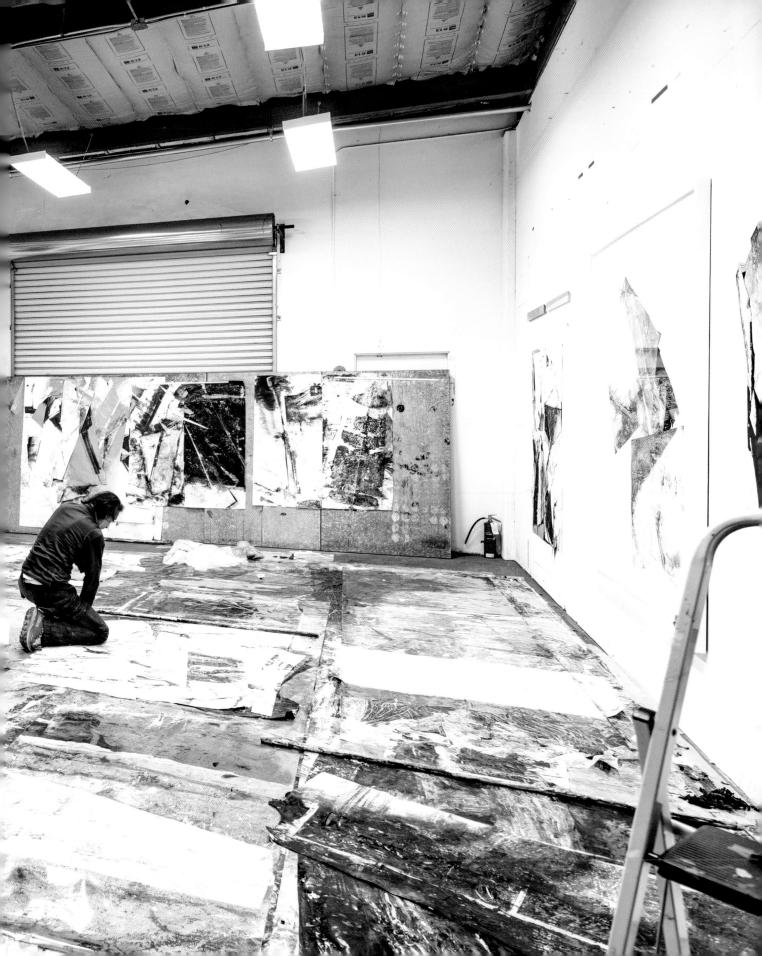

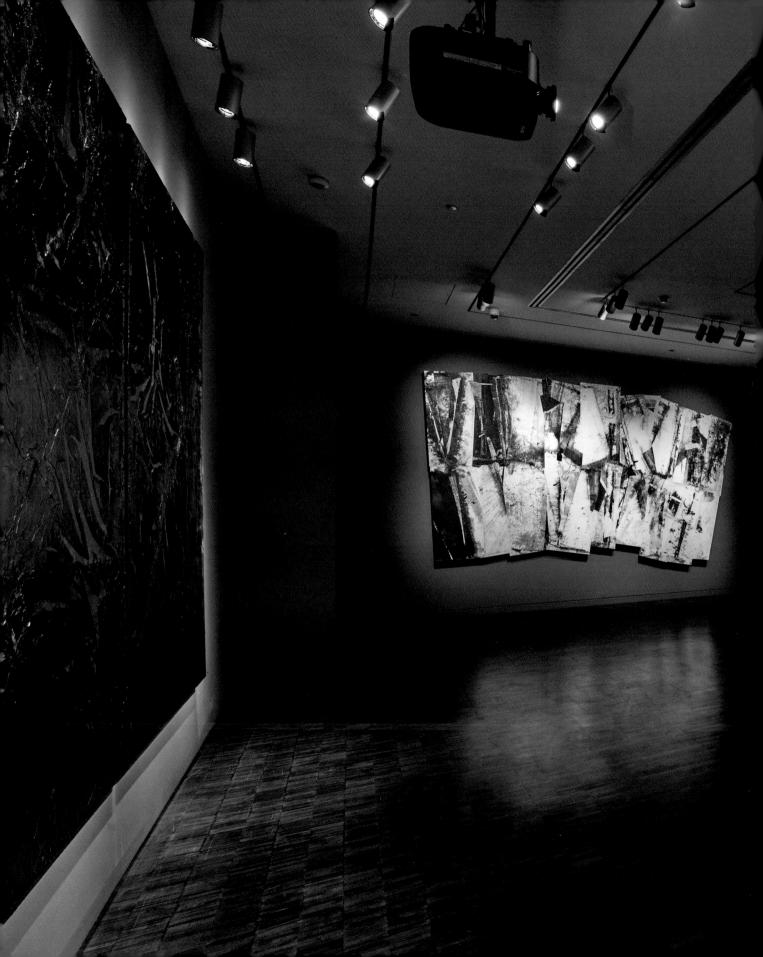

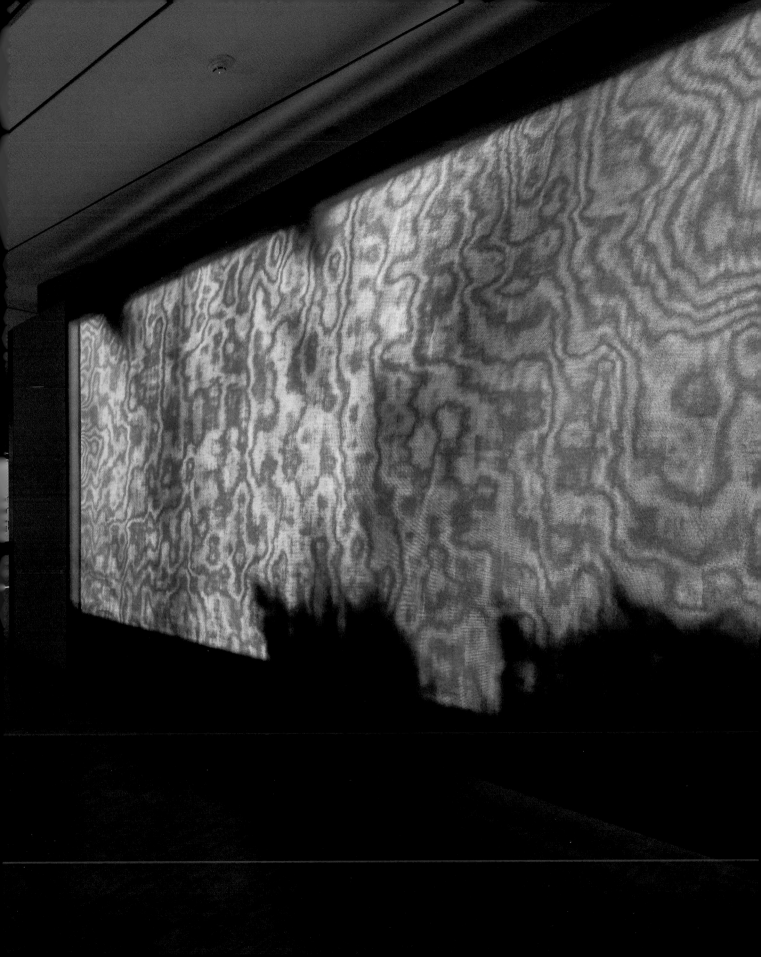

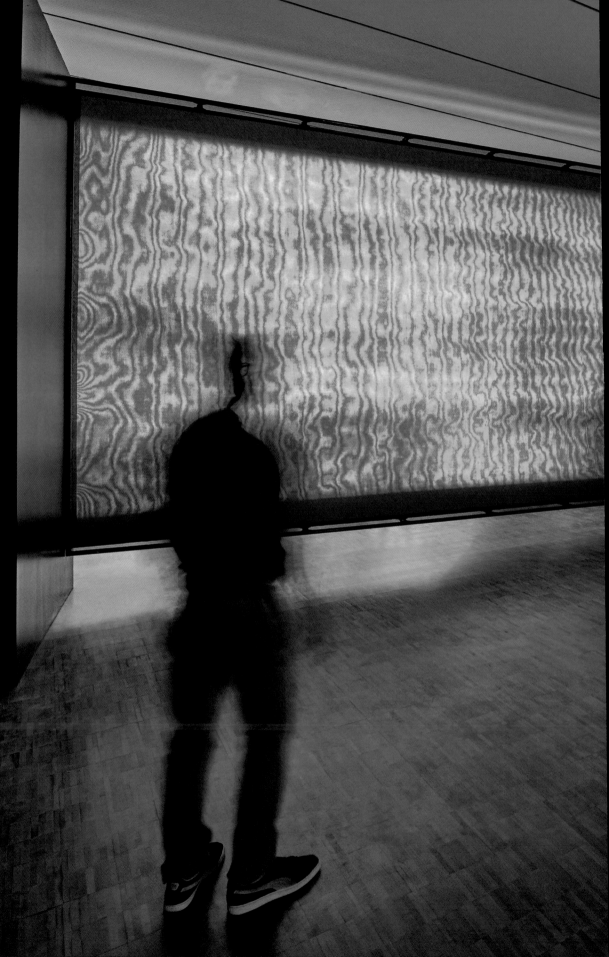

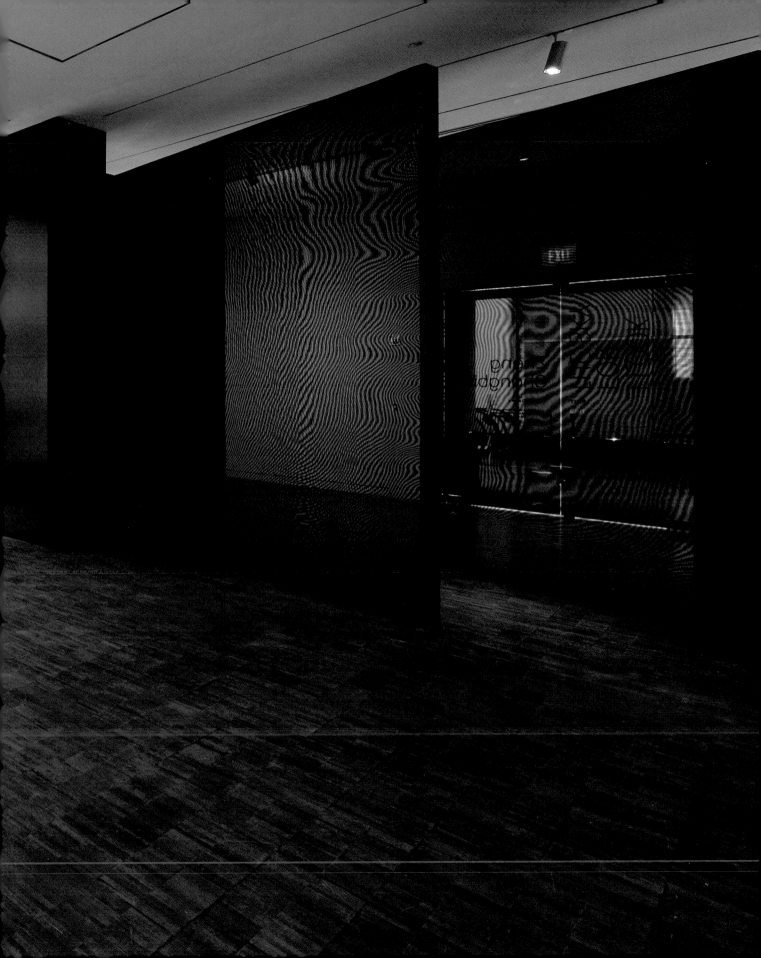

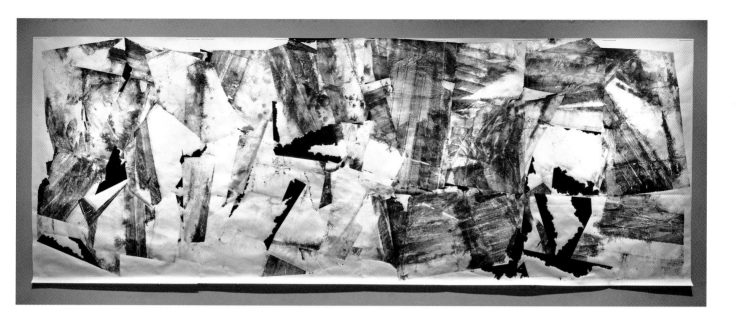

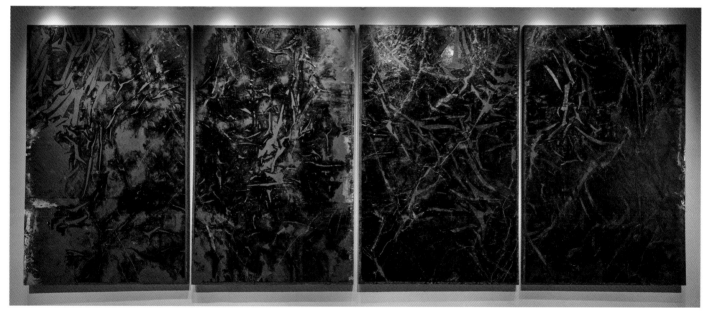

Tracing the Undulating Contours, 2017
Ink and acrylic on Xuan paper
Lent by the artist

Absent of l ight, 2020
Ink and acrylic on Xuan paper mounted
on silk with aluminum frame
Lent by the artist

ZHENG CHONGBIN

Born 1961, Shanghai, China
Currently based in San Rafael, CA, and Shanghai, China

EDUCATION

1991 MFA, San Francisco Art Institute, San Francisco, CA
1984 BFA, Chinese Painting Department, Zhejiang Academy of Fine
 Arts (now China Academy of Arts), Hangzhou

AWARDS AND HONORS

2010–11 XianRui Artist Excellence Exhibition Series Grant, Chinese
 Culture Foundation of San Francisco, San Francisco, CA
2008 Juried permanent site-specific commission at Marina Bay Sands
 Art Path, Singapore
1989–91 Inaugural international student fellowship, San Francisco
 Art Institute, San Francisco, CA

SELECTED SOLO EXHIBITIONS

2019 *Zheng Chongbin: What the Space Wants to Be*, UOB Art Gallery,
 Shanghai
 Liquid Space, Ryosoku-in Temple, Kyoto
 Dimension and Flow, Shibunkaku, Kyoto
2018 *Zheng Chongbin: Walking Penumbra*, Ink Studio, Beijing
2017 *Zheng Chongbin: Clusters of Memory*, Asia Society Texas Center,
 Houston, TX
 Zheng Chongbin: Asymmetric Emergence, Sundaram Tagore
 Gallery, New York, NY
2016 *The Pacific Project: Zheng Chongbin*, Orange County Museum
 of Art, Newport Beach, CA
 Structures, S|2 Gallery, Hong Kong
2015 *Zheng Chongbin: Wall of Skies*, Ink Studio, Beijing
2014 *Reconstruction Zone*, Microsoft Innovation Center, Beijing
 The Matter Becomes Form: Zheng Chongbin and His Ink Media,
 Asia Art Center, Taipei
2013 *Zheng Chongbin: Impulse, Matter, Form*, Ink Studio, Beijing
2012 *Negotiating between Light and Ink*, Asian Art Center, Beijing
 Amorphous Geometry, Valentine Willie Fine Art, Singapore
 Ink Phenomenon: Object of Perception, Flo Peters Gallery,
 Hamburg
 Black Wall / White Space, Hong Kong Arts Centre, Hong Kong
2011 *White Ink*, Chinese Culture Center of San Francisco, San
 Francisco, CA
 INKquiry: Zheng Chongbin, Ooi Botos Gallery, Hong Kong
 Obtrusive/Elusive: Recent Ink Work of Zheng Chongbin, Haines
 Gallery, San Francisco, CA
2010 *Zheng Chongbin: Emergent*, Valentine Willie Fine Arts, Singapore
 Rising Forest, Marina Bay Sands Art Path, Singapore
2005 *Ink and Wash Paintings*, Michael Martin Gallery, San Francisco,
 CA
1997 *East Meets East in the West*, Limn Gallery, San Francisco, CA
1990 *Humanism in the Arts*, Montgomery Gallery, San Francisco, CA
1989 *Introductions*, Bruce Velick Gallery, San Francisco, CA
 New Stone Color Ink Paintings, Riskin-Sinow Gallery, San
 Francisco, CA
1988 *Chongbin Zheng*, Shanghai Art Museum, Shanghai

SELECTED GROUP EXHIBITIONS

2019 *New Chinese Galleries*, Philadelphia Museum of Art, Philadelphia, PA
Contemporary Chinese Art Installation, Brooklyn Museum, New York, NY

2018 *Art on theMART*, theMART, Chicago, IL
Post-Brushwork Era: Chinese Landscapes, Guangdong Museum of Art, Guangzhou; Zhejiang Art Museum, Hangzhou
Ink Worlds: Contemporary Chinese Painting from the Collection of Akiko Yamazaki and Jerry Yang, Cantor Arts Center, Stanford, CA

2017 *The Weight of Lightness*, M+ Museum, Hong Kong
Streams and Mountains without End: Landscape Traditions of China, Metropolitan Museum of Art, New York, NY
Chinese Contemporary Art: New Acquisitions for the Daimler Art Collection, Daimler Art Collection, Stuttgart-Möhringen

2016 *Chinese Art Galleries*, Los Angeles County Museum of Art, Los Angeles, CA
Why Not Ask Again?, 11th Shanghai Biennale, Power Station of Art, Shanghai

2015 *First Look: Collecting Contemporary at the Asian*, Asian Art Museum, San Francisco, CA
From a Poem to the Sunset, Daimler Contemporary Berlin, Berlin
Personal Structures: Crossing Borders, 56th Venice Biennale, Collateral Event, Palazzo Bembo, Venice

2014 *Ink and the Body: Ink and Phenomenology*, Ink Studio, Beijing
A Fragment in the Course of Time: Landscape of Chinese Ink Art in 1980s, Shanghai Himalayas Museum, Shanghai

2013 *Personal Structures: Culture, Mind, Becoming*, 55th Venice Biennale, Collateral Event, Palazzo Mora, Venice
The Moment for Ink, Chinese Culture Center of San Francisco and San Francisco State University, San Francisco, CA

2012 *China's Imperial Modern: The Painter's Craft*, University of Alberta Museums, Edmonton
Ink: The Art of China, Saatchi Gallery, London

2011 *N Minutes Video Art Festival: Urban Skin*, March Art Production, Shanghai
XUAN, ETC: Zheng Chongbin, Qiu Zhijie and You Si, Shanghai Gallery of Art, Shanghai

2010 *Inaugural Exhibition of Zendai Contemporary Art Exhibition Hall*, Shanghai
Ink Code, 3rd Taipei International Modern Ink Painting Biennial, National Museum of Taiwan, Taipei
Shanghai: Art of the City, Asian Art Museum, San Francisco, CA

2009 *Calligraffiti: Writing in Contemporary Chinese and Latino Art*, USC Pacific Asia Museum, Pasadena, CA

2008 *International Contemporary Ink Art Show*, Busan Museum of Modern Art, Busan
21st Century Contemporary Ink, China National Academy of Painting, Beijing

2007 *Reboot*, The Third Chengdu Biennale, New International Convention Center of Chengdu, Chengdu

2005 *Dialogue*, Michael Martin Galleries, San Francisco, CA

1999 *From Chinese Ink to Abstraction*, Chinese Culture Center of San Francisco, San Francisco, CA

1996 *Rice/Snails/Pigeons*, Meridian Gallery, San Francisco, CA

1994 *Cultural Identities and Immigration: Changing Images of America in the 90's*, Oliver Art Center, California College of Arts and Crafts, Oakland, CA

1993 *Beyond the Written Word*, San Jose Institute of Contemporary Art, San Jose, CA

1992 *The Object Is Bound (The Book as Metaphor)*, Stephen Wirtz Gallery, San Francisco, CA

1991 *A Grave Silence*, Ghia Gallery, San Francisco, CA

1988 *Chinese Painting Exhibition*, Hochschule für bildende Künste Hamburg, Hamburg

1987 *Contemporary Chinese Painting*, Japan Gallery, Osaka

1985 *National Young Artists Exhibition*, National Art Museum of China, Beijing

SELECTED COLLECTIONS

Asian Art Museum, San Francisco, CA
Art Institute of Chicago, Chicago, IL
Brooklyn Museum, New York, NY
British Museum, London
Daimler Art Collection, Berlin
DSL Collection, Paris
Los Angeles County Museum of Art, Los Angeles, CA
M+ Museum, Hong Kong
Marina Bay Sands, Singapore
Metropolitan Museum of Art, New York, NY
Orange County Museum of Art, Santa Ana, CA
Philadelphia Museum of Art, Philadelphia, PA

ACKNOWLEDGMENTS

CONTRIBUTORS

Despite the complications of a global pandemic that began in 2019, the ambition and vision of *Zheng Chongbin: I Look for the Sky* did not change. In fact, these extreme circumstances served to affirm the original goals of the project: to transform museum space and the experience of art. With the great uncertainty faced by the museum field, it is critical to recognize that art both grounds and uplifts us, providing new pathways. This exhibition challenged preconceived notions on numerous levels and required participants to be receptive to new ideas and experimentation as we journeyed into uncharted territory. I am grateful to all those who made the exhibition possible and would like to thank those critical to this companion publication.

My foremost thanks go to director Jay Xu for his foreword, his advocacy for contemporary art at the museum, and his deeply held belief in this project. I want to thank Robert Mintz, deputy director of art and programs, and Laura Allen, chief curator, who supported the idea to publish a catalogue for an exhibition of site-specific commissions. I am deeply grateful for the tireless work of Viv Liu, research assistant for contemporary art, and their dedication in developing and organizing the content of this catalogue. I also extend my thanks to Megan Merritt, project manager for contemporary art, for her invaluable role in planning and facilitating this entire project.

I am fortunate to work with Nadine Little, head of publications, and Ruth Keffer, publications copy editor, whose patience and meticulous attention to detail improved all aspects of this catalogue, as well as the exhibition text. I also salute Kevin Candland, museum photographer, and Lorraine Goodwin, senior interpretive planner, for faithfully documenting the process behind the commissions for this publication.

Thanks are also due to Bob Aufuldish for a beautiful book design that captures the essence of the exhibition; to Maya Kovskaya for her rigorous and insightful essay; and to Clare Jacobson, who thoughtfully and intelligently edited this book. I am also grateful to Ink Studio for providing unwavering support along with additional resources.

Finally, my deepest gratitude to Zheng Chongbin for trusting in us and in our work together.

Abby Chen

Abby Chen is the senior associate curator and head of contemporary art at the Asian Art Museum of San Francisco. Chen joined the museum in 2019 to establish the Contemporary Art department and help shape the vision for the 2020 museum expansion and reopening project. Previously, Chen served as artistic director at the Chinese Culture Center of San Francisco, where her decade-long tenure transformed the community organization into a global platform for contemporary art exhibitions and public projects.

Maya Kóvskaya teaches Multispecies Anthropocene Studies, Theory, and Visual Cultural Studies in the Department of Social Sciences and Development at Chiang Mai University. She has worked curatorially on many contemporary art exhibitions, including *Zheng Chongbin's Chimeric Landscape* (2015), and has authored, co-authored, edited, translated, and contributed to numerous books and articles writing on the intrasections of Asian art with the ecological, the political, and the semiotic. Kóvskaya completed her PhD at UC Berkeley in 2009.

Zheng Chongbin studied classical ink painting at the China Academy of Art in Hangzhou, as well as conceptual and performance art at the San Francisco Art Institute. Through his practice Zheng aims to convey and capture the vitality of matter and the way that order emerges from chaos. In his abstract paintings, he works to demonstrate (rather than illustrate) processes found in nature, through the organic interactions of ink, acrylic, paper, and light. In his videos and installations, Zheng explores the structures that comprise the world—from cellular systems to solar systems.

Viv Liu is the research assistant for the Contemporary Art department at the Asian Art Museum of San Francisco. Liu graduated from Stanford University with a BA in art history and comparative studies in race and ethnicity.